The Action Camera Handbook

Getting the Most From Your Action Camera

Jim Mohan

Copyright © 2016 Jim Mohan

All rights reserved.

ISBN-13: 978-1537048789

ISBN-10: 1537048783

DEDICATION

To all the extreme sports athletes, adventurers and photography buffs who share their exploits with us via photographs and videos.

Contents

DEDICATION .. iii

Chapter 1 Getting Started ... 1

Chapter 2 Camera Form Factors .. 3

 Introduction .. 3

 Rectangular Box Cameras .. 3

 Square Box Cameras .. 5

 Tubular Cameras .. 5

 Side-Mount Lens Cameras ... 6

 Conclusion .. 7

Chapter 3 Camera Lenses and Sensors .. 9

 Introduction .. 9

 Camera Sensors .. 9

 Image Sensor Sizes .. 10

 Pixel sizes ... 11

 Camera Lenses ... 12

 Wide Angle Lenses ... 12

 Fixed Focus Lenses ... 14

 Conclusion .. 15

Chapter 4 Camera Controls .. 17

Introduction .. 17

Camera Smartphone Apps .. 17

Basic Camera Controls .. 18

Conclusion. .. 20

Chapter 5 Camera Settings .. 21

Introduction .. 21

Video Mode Menu .. 21

Camera Mode Menu .. 24

Miscellaneous Menu .. 25

Settings Menu .. 28

Exit mode. .. 29

Conclusion ... 29

Chapter 6 Camera Accessories .. 31

Introduction .. 31

Housings and Harnesses ... 32

 Housings .. 32

 Harnesses .. 33

 Harnesses for People ... 33

 Harnesses for Pets. .. 34

- Attachment Techniques .. 35
 - Adhesive Mounts ... 35
 - Bike Mounts ... 36
 - Clip Mounts ... 36
 - Suction Mounts ... 37
 - Float Mounts ... 38
 - Selfie Sticks ... 38
 - Miscellaneous Connectors .. 39
 - Lens Protection and Filters .. 40
 - Extra Batteries .. 41
- Conclusion .. 42

Chapter 7 Camera Gimbals .. 43

- Introduction ... 43
- What Gimbals Do .. 43
- How Electronic Gimbals Work .. 44
- Gimbal Levels and Features ... 44
- Gimbal Modes .. 46
 - Heading Follow Mode. ... 46
 - Locking Mode. .. 47
 - Heading and Pitch Follow Mode. 47

- Reverse Mode ... 47
- Controlling the Gimbal ... 48
- Extension Poles .. 49
- Conclusion ... 50

Chapter 8 Quadcopters and Drones 51

- Introduction .. 51
- How Drones Work ... 52
- Using Drones as a Camera Platform 53
 - Camera and Gimbal Choices ... 54
 - Flight Modes and GPS .. 55
- Commercial vs. Personal Use ... 56
- Drone Safety ... 57
- Conclusion .. 57

Chapter 9 Getting The Most From Your Action Camera 59

- Introduction .. 59
- Get to Know Your Camera .. 60
- Telling the Story ... 61
- Planning the Shots ... 62
- Shooting B-roll ... 64
- Using Multiple Cameras .. 64

Capturing Sound .. 65

Kinds of Microphone ... 66

 Microphone Types .. 66

 Microphone Styles .. 67

Using Separate Audio Recorders ... 67

Conclusion .. 69

Chapter 10 Editing Your Footage ... 71

Introduction .. 71

Editing Software ... 71

 Editor Workspaces ... 72

Editing as an Art ... 74

 Quick Hits and Multiple Perspectives .. 74

 Software Tools and Effects .. 75

 Fisheye Correction ... 76

Some Legal Stuff .. 79

 Privacy ... 79

 Copyright ... 80

Conclusion .. 81

Chapter 11 Ten Tips for Action Cameras 83

Introduction .. 83

The Ten Tips	83
Bonus Tips	85
Conclusion	85
Photo Credits	86
ABOUT THE AUTHOR	87

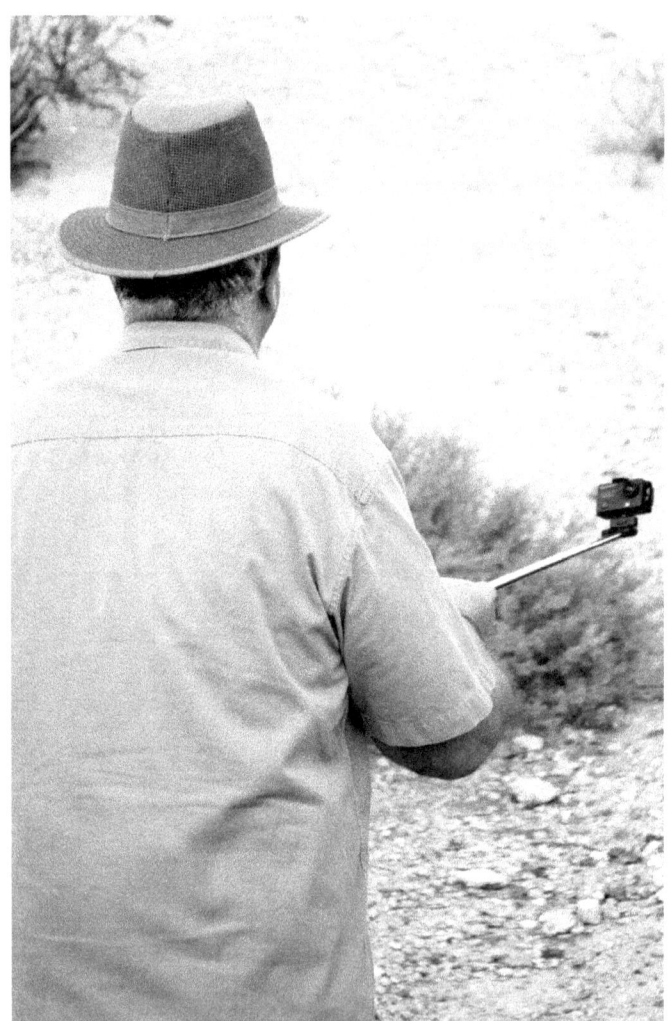

CHAPTER 1
GETTING STARTED

It's hard to believe that it's only been a decade or so since the first small digital action camera hit the market – the GoPro Digital Hero. With 10 seconds of video recording at VGA resolution it was a market maker and the world of digital video was changed forever.

Today the GoPro is the market leader in small digital video recorders most commonly referred to as action cameras or action cams. As with any breakthrough product, it wasn't long until others jumped into the market too. Today there are a large number of recognized as well as unrecognized brands filling the action cam market with models priced from about $30 to nearly $500 not counting small specialty cameras.

The GoPro is at the top of the list for consumer level action cams in both quality and price. Its popularity is well deserved and the fact that much like a facial tissue is often called a Kleenex, the GoPro brand name has come to stand for the product category itself, even though both are registered trademarks of their respective owners.

For the beginner or casual user, a $400 price plus more for

accessories can be a daunting challenge. The good news is that there are several action cameras in the sub-one hundred dollar range that provide a wide feature set and good photo and video results. This is particularly good news for the budding film maker who wants to duplicate some of the current TV reality show settings with multiple cameras capturing conversations inside cars, POV (point of view) shots directed at both the cyclist and at the road ahead simultaneously and helmet mounts and chest mounts capturing the same ski run, bungee jump or skate park obstacle.

When you match these small video cameras with free or inexpensive video editing software, free distribution on YouTube or Vimeo and some creativity the results can be surprising. Travel writers can take their blogs to the next level, extreme sports enthusiasts can document their accomplishments and families can easily document routine daily life for a video history treasured for years to come.

The purpose of this handbook is to acquaint you with some of the features, accessories and uses you'll want to consider to get the most from your new action cam. I purposely didn't focus on any particular camera brand or try to provide a buyer's guide. There are lots of reviews online for that and new models and features appear fairly regularly. Such a document would likely be out of date before it was published. I did, however, choose to deal with examples from the low to middle end of the price range. Again, this was to encourage those on the fence about purchasing an action cam to give it a try using only a modest investment. When you decide how much you like using your new action cam, you can start saving for one of the top-of-the-line brands or models.

The other purpose for this book is to fill a void when it comes to instructions. Many low priced cameras come with little more than a list of features and a diagram of where the buttons are. Here we'll explain what it all means.

Let's get started.

CHAPTER 2
CAMERA FORM FACTORS

Introduction

When most people think of an action cam they envision the small rectangular box with a lens on the upper right corner. That form factor is the most common but not the only one in the market. There are also square cameras, tubular cameras, cameras with their lenses mounted on their sides and others. Let's take a look at several of the more popular shapes.

Rectangular Box Cameras

Rectangular box cameras are what most people envision when the term action cam is mentioned. These small cameras are usually about 58mm X 40mm X 29mm (L, H & W) plus or minus a millimeter or two. The lens is mounted to the front of the camera, usually in the top right corner when looking at the device. The front of the camera also often sports the power switch which doubles as a mode selection switch, a white LED for illumination and in many cases a second display panel where key mode information is displayed. Second displays

make it easy to see key camera settings from the front side of the camera.

Many rectangular box cameras have either an LCD display on the back or slots for what is often referred to as an LCD backpack. LCD backpacks are separate displays that plug into the camera but can be removed to save weight or power when the camera is in use. The backpack adds several millimeters to the width of the camera and must be considered when purchasing some accessories, especially generic, third party ones.

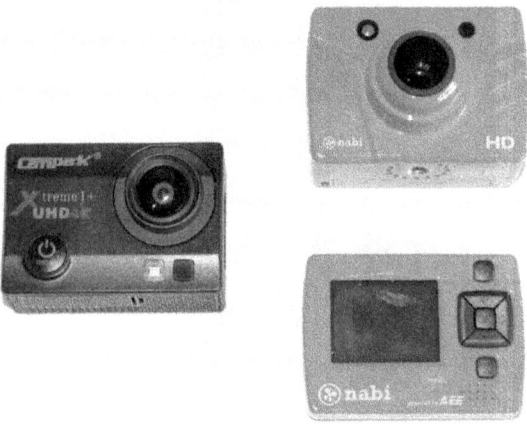

Figure 1. Two action cameras, one with an embedded LCD display and one with an LCD backpack attachment.

Camera settings are selected using the mode selection button, up and down selection switches and an OK or select switch. More expensive cameras use the rear LCD screen with touch screen technology. The final couple of items you'll find on many of these style cameras is the micro SD card slot, a pin hole microphone, a mini or micro USB port and in some cases a micro HDMI port to output video directly to a monitor or

HDTV.

Much of the case interior is taken up by the battery. Batteries are normally accessed by a door on the bottom of the case.

Square Box Cameras

Square box cameras are another common form factor. They have a square face but they are not necessarily cubes. Sizes vary but expect to see something about 40mm X 40mm. These cameras will have the lens centered on the front and the LCD screen centered on the rear of the device. Depending on the model, the battery, USB ports and micro SD slots will be mounted on the sides either behind doors or not. For cameras not designed to be waterproof, you can expect the camera to come with a waterproof housing for underwater use.

Tubular Cameras

Tubular cameras look a lot like lipstick tubes – big lipstick tubes. The cameras are about 110mm long and 40mm in diameter. Since they are round, you'll need to stick with the manufacturer's accessories for the most part. One interesting application for cameras with this form factor is a camera mount below a shotgun or rifle. This view provides the shooter's view of the hunt or clay pigeon shooting. When properly aligned, they can be used as a practice tool to improve the shooters aim or lead on a moving target.

Tubular cameras normally have an internal battery that's charged through a USB cable via your computer, car or AC adapter, or external lipo battery charger. The various ports are often hidden under a spring clip door or screw-off cap on the end opposite the lens.

One of the advantages of this form factor is the small front face of the camera. These can be easily attached to a helmet using accessories or just taped on using duct tape. In other settings, the small 40mm front face makes for an

inconspicuous camera helping to prevent people from changing behaviors due to the presence of a camera. See Chapter 10 for some important information regarding privacy and state recording laws.

Side-Mount Lens Cameras

Side-mount lens cameras are small form factor cameras normally found without screens. A couple of examples of this form factor are the Spy Tec Mobius Mini Sports Cam, the RunCam Mini Sport Action Cam and at the more expensive end of the price range, several Sony models with up to 4K video capture.

The Mobius and RunCam models are favorites in the radio controlled model world. These cameras are small enough to mount on even the smallest RC cars, drones, and even light-weight foam airplanes. These cameras allow a pilot's or driver's eye view of the action.

Figure 2. A RunCam brand side-mount lens action cam on a radio controlled model airplane.

I've been using these style cameras for several years on my model airplanes. They are easy to use with limited options.

Basically, you simply set them for either photo or video mode and click the shutter. In video mode they start recording and stop when the shutter is clicked again. They can be set up as an automobile dash cam and can do loop recording to overwrite existing video when the memory card fills up.

Depending on the model plane or car, they can be stuck to a fuselage, wing, roof or other surface such as a mount behind the windshield. They are HD capable and provide nice images of the flight or trip around the track.

The Sony cams can be used similarly but have an expanded feature set and more recording options as you would expect from a camera in the $250 to $500 range. These cameras include several mounting accessories, a remote control and waterproof external shell. Smaller than a deck of cards, this form factor, like the tubular form factor allows for less obtrusive recording than the rectangular box cameras.

Conclusion

For the person just getting started with action cameras, the rectangular box cameras are likely going to be your first choice. They can be had for a range of inexpensive prices and are similar enough in size to work with just about any set of accessories available with little or no modifications. This full range of accessories will allow you to try your hand at a variety of effects and shots using various points of view. We'll discuss this point more fully in Chapter 6.

Tubular and side mount lens cameras like the RunCam can be good choices for small action cams to solve a specific problem such as when a small profile and light weight is required or for obtaining airborne footage. However, the more traditional rectangular form factor will likely be most people's best choice.

Notes

CHAPTER 3
CAMERA LENSES AND SENSORS

Introduction

The primary technology advancement in photography and videography in the last couple of years has probably been the huge improvement in digital image sensors. A digital camera with a 2 megapixel sensor was a big deal just a few years ago and that sensor was mounted in a full sized SLR camera body. Since that time engineers and computer scientists have been able to cram a huge number of pixels into truly tiny sensors.

Consider your smartphone. The small lens on the back often feeds a 16 megapixel sensor and the tiny front-facing lens feeds a 3 megapixel sensor. Wow. Let's take a brief trip into the technology behind these sensors.

Camera Sensors

In our digital cameras, the image sensor is packed with pixels or more accurately, photosites. Those photosites collect photons during the exposure. The camera then tries to decide

how many photons are in each photosite to determine the intensity of the charge. Through the use of red, green and blue filters covering various photosites the image sensor and related electronics can build a color image from these charges. Since this isn't a science class, let's leave it at that high level.

Image Sensor Sizes

Digital image sensors come in a variety of sizes. Since at the beginning of the digital photography revolution the standard was the 35mm film frame and lenses were configured to project the image at the film's dimensions. That 35mm convention remained the standard for digital cameras too.

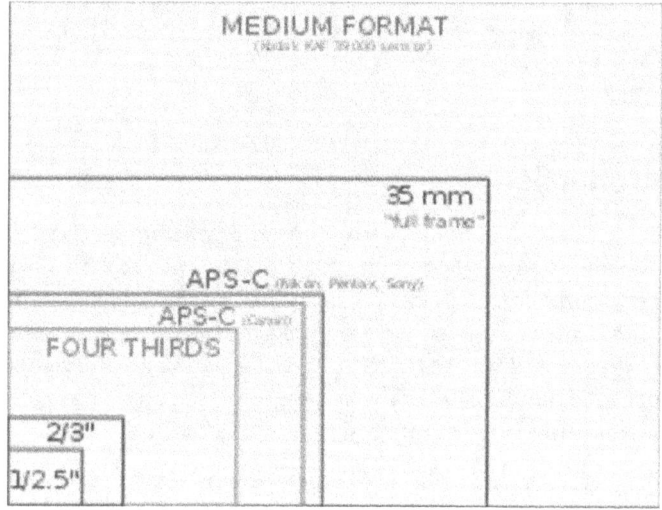

Figure 3. Relative size comparisons of typical image sensors.

When you see a 'full frame' digital camera, you're looking at a camera with an image sensor with the same size as a frame of 35mm film, that is, 36mm X 24mm. (No, I don't know why it isn't called 36mm film.) Those cameras are quite expensive. The next step down in consumer level cameras is called a cropped or DX-sized sensor. These sensors are smaller than a full frame sensor and much less expensive. Again, staying in

the DSLR camera arena, the DX sensor is said to have a crop factor of about 1.5. That means that a lens for a full frame camera would overshoot the sensor size with its image. A full frame camera's sensor is about 2.3 times larger than a DX-sized sensor in terms of area.

When we get down to the sensor sizes used in smartphones and action cams we're usually looking at sensors in the 1/2.6 category. Those tiny sensors are only about 4mm X 5mm large. That means a full frame sensor is about 38 times bigger than the one in an action cam. Since these sensors can still hold 12 or 16 megapixels, does size make a difference? In a word, yes.

Pixel sizes

Large image sensors have larger pixels or, more accurately, photosites. It has to be for a 16 megapixel sensor that's 36mm X 24mm to have the same pixels as an action cam sensor that is 4mm X 5mm.

Larger pixel sizes allow more light to strike each photosite and each photosites to collect more photons than a smaller photosite can. This charge is what is used to translate the light into a digital image. A smaller photosite uses the same process but due to its size, produces a smaller electron charge. That is part of the reason your small-sensor action cam works pretty well outdoors on bright days, but it's also why its performance suffers indoors or on dreary days.

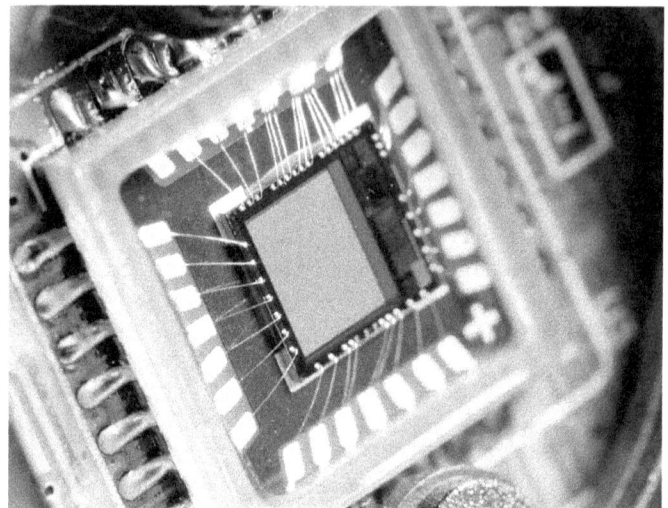

Figure 4. A tiny image sensor mounted to its circuit board.

Camera Lenses

The lens on your action cam will normally be a wide-angle, fixed focus lens. Let's explore those two concepts briefly.

Wide Angle Lenses

As the name suggests, a wide angle lens captures a broad expanse of the view in front of the lens. In DSLR cameras, this is accomplished by having a short focal length. Focal length is the distance from the lens' point of convergence to the camera's sensor.

Our action cams work a little different. Check the specifications on the action cam you are looking at to see the degrees of coverage your camera's lens picks up. It's not unusual for inexpensive action cams to have lenses in the 150 degree to 170 degree category. What that means is the camera's lens will allow light from the scene covering nearly all the arc of the semi-circle before you onto the sensor.

With your action cam this is accomplished by shaping the front side of the lens with a convex surface like a fish's eye. The shape of the lens allows a wider field of view with a noticeable downside. The downside is that lines in the image near the edges are curved. That is because the light bends coming through the lens and is not straightened within the lens.

This curved effect is noticeable in most action cam footage and photos. For example, a scene with a beautiful landscape will have a noticeable curve to the horizon rather than a straight line. In other cases, buildings that you know have vertical walls will also appear curved.

Figure 5. Notice the horizon's pronounced curve due to the lens' fisheye effect.

Fortunately, since the image is a digital image, video editing tools will allow you to remove the fisheye effect and straighten out the lines. Some more expensive actions cams allow you to limit this in the camera by essentially cropping the outer edges of the sensor where the curves appear, in effect, narrowing the field of view. Terms may vary but essentially the camera simply cuts a few degrees off the total field of view to remove some

of the curves found on the edges.

Fixed Focus Lenses

Point and shoot cameras like your action camera do not have a focusing mechanism like larger DSLR and some other pocket sized cameras. Manual focus is usually not supported either. In this case cost and the ability to see the image on the tiny camera LCD are the likely culprits. Auto focus systems take space and will cause the camera to weigh more. Since both space and weight are important in an action cam, focus is dealt with differently.

Again, we need to take a bit of a side trip.

This time we'll need to delve into some photography minutia. Fixed focused lenses capture focus within a large depth of field using a concept called 'hyperfocal distance.' This distance is the distance the camera should be focused at to allow an acceptable focus from half that distance to infinity. This distance is computed with a mathematical formula that takes into consideration three variables. They are the camera's focal length, the aperture setting and a variable referred to as the sensor's circle of confusion. Since you probably won't have easy access to any of these specifications you can back into it if you're interested.

A table top test of your camera's close in focus distance is sufficient for most people. Lay a tape measure or yard stick out on the table and take multiple shots moving the target closer and closer to the camera and then examine them in your computer's photo editor or viewer. I'd start at about 15 inches and move closer to the camera inch by inch. In most cases, you'll find that you start to get a soft or unfocused image in the 8 – 12 inch range. That means the hyperfocal distance is somewhere around 16 - 24 inches. Keep the distance where focus starts to soften in mind when setting up your shots. That means that you'll be OK closing in to about a foot for your close-ups. Your long shots will remain clear. What you won't

be able to do is achieve cinematic effects such as soft backgrounds but hey, its an action cam!

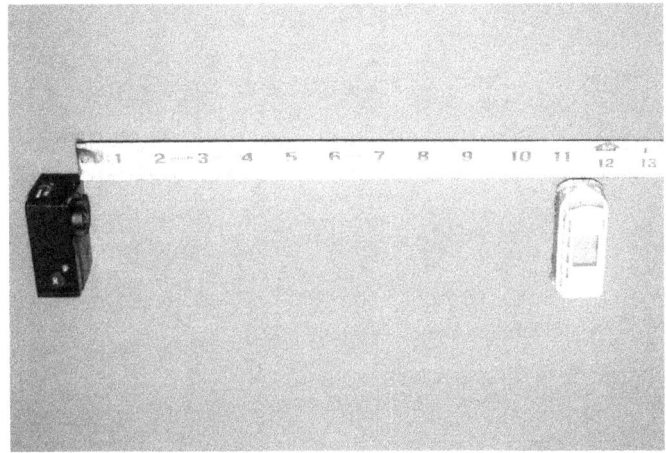

Figure 6. Using a tape measure and small target to determine close-up focus distance. Twice that distance is a reasonable approximation of your camera's hyperfocal distance.

Conclusion

Even your inexpensive action camera is a very sophisticated device. Understanding how it works in even a general way will help you get the most from your footage and photos. With this basic knowledge and an understanding of your camera's controls discussed in the next chapter, you'll be well on your way to capturing some great shots.

Jim Mohan

Notes

CHAPTER 4
CAMERA CONTROLS

Introduction

When you're talking about a camera whose dimensions are measured in millimeters, there is not a lot of room for a bunch of controls. Since even inexpensive action cams have a wide variety of functions and variables, they solve that problem with menus and menu trees displayed on the rear LCD screen.

Inexpensive action cams usually use mode, movement and selection buttons to navigate those menus. Higher priced models may have touch screens that allow you to touch the menu choice instead of clicking up and down buttons to highlight your selection.

Camera Smartphone Apps

With the addition of Wi-Fi to action cameras, many cameras have free apps available at the various app stores that allow you to change many of the settings using the larger touch screen on your smartphone. These apps also allow viewing the image the

camera is seeing, starting and stopping recording and triggering the shutter for still shots. You can also download video and photos to the phone for easy sharing on social media. This Wi-Fi connectivity really simplifies dealing with such a small form factor camera.

Basic Camera Controls

The controls listed here are typical of the ones you'll find on many action cameras. They may have slightly different names or be located on the camera in different places but they will perform the same functions.

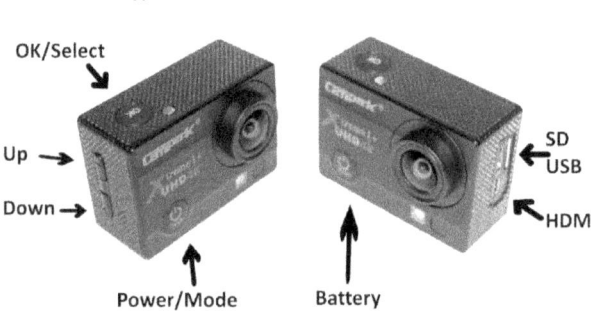

Figure 7. Typical action camera control locations.

Mode Selection. On one of my action cameras, the power button doubles as a mode select switch. When the camera is on, pressing the mode button briefly changes the camera's function from video to stills to slow motion to a file browser/viewer to the settings menu.

OK/Select/Shutter Button. The OK button on the top of the camera starts and stops video recording, acts as the shutter release when in still camera mode and selects the highlighted option when in menu mode.

Up and Down Buttons. Two buttons on the side of the camera control up and down movement when selecting menu options. On my sample camera, pressing the up button for several seconds turns the Wi-Fi on or off.

You'll notice that the position of these buttons changes from camera to camera. That's why most cameras come with their own waterproof housing. The housing has matching button locations so the housing is not likely to fit a camera other than the one for which it was designed.

Card Slots. Most actions cams use a micro SD card to record photos and video. The tiny card is slipped into a slot with a bit of spring tension to it. If the card doesn't go in easily flip it over. It's sometimes hard to guess what way the label will be facing though the contacts always go in first. SD cards used to record video should have a rating of class 10 or higher. Newer high speed SD cards also use the moniker UHS -1 and UHS-II to indicate they are rated for very fast data transfer. Cards rated less than class 10 may cause jumpy video as data is lost when the card data transfer gets backed up. Cards are cheap. Get fast ones. You'll also want to see what capacity card your camera will accept. Most take up to 32GB without issue. Some firmware cannot address all the memory in a 64GB SD card. Check before you buy.

USB Ports. Action cams will usually have either a mini or micro USB port. You use the port and the included cable to connect to your computer or a USB battery charger. You can also use the cable to transfer files to your computer. On a Windows computer, your camera will show up in Windows File Explorer. When you expand the directory you'll see the files on the SD card. From there you can select or drag and drop the files to wherever you store your photos and videos.

Microphone. If you look closely at your camera's case you see a small hole or two in the plastic. That is most likely the camera's microphone. These little pin hole mics normally aren't very good but are better than nothing. If you are

working on a big production you'll probably be recording your audio via a separate audio recorder. If that's the case, the camera's mic will be fine for capturing the base or scratch track that will allow you to marry the audio recorder's audio to the video in post-production. It's often helpful if someone on camera claps or you use a slate clapper to help with post production audio matching when using a separate recorder.

Speaker. Action cam speakers are just as bad as their microphones. Again, if you look carefully you'll find a small set of holes in the case that allows the speaker's sound to emerge. You'll be able to hear good enough to know if sound is being recorded but it won't be a good estimate of the quality of what you've captured.

HDMI Ports. High quality video ports can sometime be found on even inexpensive action cams. These will normally be a micro HDMI port. You'll have to purchase your own cable, but with it, you'll be able to display your videos and images directly on an HDTV or monitor with an available HDMI port.

Conclusion.

Your action cam is a pretty simple device to operate. In the next chapter we'll look at the menus and settings that will allow you to get the best images possible and make the best use of your camera.

CHAPTER 5
CAMERA SETTINGS

Introduction

The camera's settings are accessed through the camera settings mode. Most action cams will group their controls under a main menu of four or five subtopics. Those topics are often depicted by icons to conserve space. Other cameras just have a long list of settings without menu groupings.

For actions cams without touch screens, you navigate through the menu using buttons on the camera. For cameras with touch screens, you simply touch the menu item to select it.

Let's take a look at what you can expect to find.

Video Mode Menu

The video mode menu allows you to select the video size or resolution and the frame rate you'll use to record your action footage. Your camera's specification sheet will describe what options you'll have. You'll want to check the product description before purchasing your camera as the choices vary.

The video mode will be described by two numbers. The first is the picture size and the second is the frame rate.

Picture Size. Picture sizes of 1080 X 720 and 1920 X 1080 pixels are both considered high definition. The labels refer to the second number in the picture's dimensions. 1080 is the preferred setting for HD as it captures more digital information. Shooting at 720 is often required when using higher frame rates as the camera's image processor may not be able to handle the data throughput at higher resolutions.

For cameras that offer 4K recording the labeling changes a bit. Instead of using the height dimension of the picture, ultra-high def resolution is a close approximation of the length of the image. That means a 4K image will be 3840 X 2160 and a 2.7K resolution is 2704 X 1524 pixels.

Frame Rates. Frame rates represent the number of video frames that are recorded each second. Movies are normally recorded at 24 frames per second (fps) and TV sitcoms and reality shows are often recorded at 30 fps. Both of these settings produce a blur factor that we're used to seeing, not only on TV or in the movies but also in normal life.

Frame rates of 60 fps produce images that are very sharp and clear but may seem a bit off. For example, instead of being a bit blurred, the wheels of a car will be clear enough to see the white letters. The difference is subtle but your mind will be telling you something isn't quite right.

Sixty and 120 fps allow you to capture fast action and turn it into slow motion in your video editor. A frame rate of 60 fps will allow for a slowdown of a factor of two and 120 fps allows for a factor of four. Cameras that allow 120 fps will likely limit that to a 720p resolution. Again, the small image processor in the action cam won't be up to the task for higher resolutions with high frame rates.

Both 4K and 2.7K video will be a challenge for your camera's image processor. At this writing, even though cameras claim

4K or 2.7K resolutions, the output will likely not be that good. You can expect some dropped frames or jerkiness in the video. Since 4K TVs and computer monitors are still few and far between, you'll likely not have a reason to record in those settings anyway. Where those higher resolutions do come in handy is when rendering your videos in 1080p. With a 4K capable video editor you can pan and zoom in quite a bit while still having enough digital data to have a 1080p image without pixilation. Realistically, however, today that will require a 4K capable handycam or other larger, more powerful camera.

Continuing with Video Mode choices, here are a few more options you can specify.

Sound Recording. This option allows you to turn the microphone on and off. Sound recording in action cams is normally not too good but a silent video is no fun. If you do some post production, you can use the camera's audio to match separately recorded sound from an external mic and recorder. More on that later.

Time Lapse. This setting allows you to set the interval the camera will take shots resulting in a time lapse recording. On my sample camera the choices are close (off), 0.5, 1, 2, 5, 10, 30 and 60 seconds. You can use this setting to shoot a pretty sunset or convey a sense of time passing when shooting a street scene.

One second intervals are good for street scenes and two to three second intervals are good for sunsets. Those pretty videos where the stars move across the sky use 20 to 60 second intervals. Remember, when played back, you'll be seeing 30 frames per second in real time so a one second interval for one minute results in only two seconds of video.

Loop Recording. Loop recording allows you to record a specific length of time and then start over. My sample camera has loop recording times of close (off), 2, 3 and 5 minutes. You can use this with the camera in dash cam mode where it starts when your vehicle is turned on and records in a loop of the

specified time. The result is each video will be the last minutes of what was recorded for the time specified. If there is something you want to ensure is recorded, you'll need to stop the recording to save that particular loop.

Slow motion. This setting determines the video resolution and frame rate for the slow motion mode. Again, in my sample camera, the choices are 1080p 60 and 720p 120.

Camera Mode Menu

The camera mode menu has the following settings:

Photo Resolution. As with video, you'll have the opportunity to make some resolution choices in the camera menu, too. In my sample camera I can choose 2, 5, 8, 12, and 16 megapixels for still shots.

 If you know how you plan to use the photos you'll be taking, choosing a lower resolution will give you space for more shots on your memory card. Two and five megapixel shots are fine for images that you'll be sharing on social media or putting on your web page. Even then, you'll likely be shrinking the images to make them fit. For photos you plan to print, the smaller megapixel choices will still be fine for 4 X 6 prints.

The larger megapixel values can be saved for images you plan to print in extra-large sizes or with images where you plan to use your photo editor to zoom in on a small portion of the image and do some cropping. In that case, the higher resolution will allow you to blow up part of image without pixilation and the jagged edges that occur when zooming beyond a reasonable limit.

Timed. The timed setting allows you to set a timer to delay the shot. This can be to give you enough time to be in the picture or allow you to avoid vibrations when you have the camera on a tripod. On my camera the options are closed (off), 3, 5, 10, and 20 seconds.

Auto. The auto setting allows you to trigger the shutter and have the camera take a shot every several seconds. This is similar to the time lapse setting in the video mode except the output is individual images. For example, instead of recording a video of your trip down the ski slope or on that perfect wave, you can set the camera to take a series of still shots. On my sample camera the choices are closed (off), 3, 10, 15 and 20 seconds.

Drama Shot. Drama shot is a setting that tells the camera to take several photos per second. This is normally used to photograph action using multiple stills. The resulting images can be layered together in your photo editing software or you can just choose the best of the shots for whatever you're trying to accomplish. My camera allows for close (off), 3, 5 or 10 photos per second.

Miscellaneous Menu

The miscellaneous menu has some additional settings to control the quality of your video and photos. The settings on my inexpensive action camera are as follows:

Exposure. On a DSLR or other larger full featured camera, exposure can be adjusted by shutter speed, aperture or ISO. We don't have direct control of any of those variables in most action cams but the exposure control in this menu can be very helpful in capturing the best quality video or stills you can.

On my sample camera I can increase or decrease the exposure three levels each way. The settings are -3, -2, -1, 0, 1, 2, and 3. Zero is the standard setting. Negative numbers allow you to limit the light the sensor reports and the positive numbers allows you to increase it. Using this setting you can adjust the brightness of your video or photos depending on the ambient light. For example, you might choose to increase the exposure when your hiking trail takes you into the woods where there is a lot of shade. On the other hand, you might choose to decrease exposure on a bright, sunny day at the beach.

White Balance. The camera will do some light metering so the auto setting will likely work most of the time. However, if you find the tint of your photos or videos is either too blue or too yellow, you have a white balance problem. When the camera knows what white is supposed to be, it can properly render the other colors.

Light is measured in degrees Kelvin. Different light sources have different temperatures and thus white can appear off if the camera misreads the light's temperature. My camera allows me to set Auto, Sunny, Cloudy, Incandescent Light and Florescent Light. If you're shooting on a cloudy day and have cloudy selected in the white balance option, you're more likely to get an accurate rendering of the colors in the scene. Likewise with the other settings. You can do some white balance correction in your photo or video editing software but getting it close in the camera is the best plan.

Light Source Frequency. This setting tells the camera whether the lights flicker at 50 or 60 hertz. Sixty hertz is the frequency of AC power in the US. Other countries use 50 hertz. Select the option that's right for where you are.

Wi-Fi. Wi-Fi turns the camera's Wi-Fi hotspot on and off. This allows the camera to communicate with its smartphone app. Wi-Fi puts an extra strain on the battery so don't use it when you're not planning to use the app. Phone apps have different features but most will allow you to control at least some of the settings from the touch screen of your phone, start and stop recording, trigger the shutter in still camera mode and download content for easy sharing on social media. The Wi-Fi options are selected or not selected.

Image Rotation. Image rotation allows you to rotate the recorded image 180 degrees. The choice is selected or not selected. You'll use this setting when your mounting system is best situated with the camera upside down. Some gimbals end up with the camera upside down when held pointing down. Use image rotation in that case, too.

If you're in a rush, don't mess with it. You can rotate images in most video editors. Do adjust it if you're planning on uploading your footage directly to social media through the camera's phone app.

Driving Mode. Driving mode allows you to set up the action cam as a dash cam. When connected to the car's power system through a USB cable, the camera will turn on and start recording when the car is started. The choices are selected and not selected. There are a couple of things to check, though. Some cameras need to have their batteries removed to work in this mode. The batteries take over when the power from the car is removed so recording doesn't end. Some cars have unswitched 12 volt sockets where round USB chargers are plugged in. Those connections don't remove power when the car is turned off either. When plugged into one of these outlets, the camera keeps recording. Check to see if you have a switched 12 volt connector somewhere.

Most cars will keep the radio and other electrical systems powered for a few minutes after the car is turned off. If you're testing your dash cam function, be sure to open the door or take whatever other action your car senses to cut power to these devices to see if your camera shuts off.

Auto Screen Saver. The auto screen saver blanks the rear LCD screen to save battery power. The settings on my sample camera are close (off), 10, 20, and 30 seconds. You'll want the screen on long enough to set up the shot or make changes without having to click the OK button to display the screen again but not so long that you eat up your batteries.

Auto Shutdown. The auto shutdown allows you to choose how long the camera stays awake with no activity. Again, it's a battery saving tool. My camera allows close (off), 1, 3, and 5 minute delays. Auto shutdown options aren't always the best. It can be quite frustrating to stop and turn the camera on between shots. Give some thought to your activities and pacing to help ensure the camera is ready when you are.

Always-on camera settings increase battery usage so have a spare or two at the ready.

Time watermark. The time watermark will add the camera's time and date onto the video or photo you capture. Personally, I find this distracting. The video or photo file will include time and date information in the metadata so having it displayed on the video itself is not necessary. If there is some point you want to make about when the video was taken, you can easily add it in as a title element in your video editor during post production. The choices are selected or not selected.

Settings Menu

The settings menu has a couple of items regarding general camera housekeeping. On my camera they include:

Language Choices. Language choices allow you to change the language used in the menu screens. Cameras usually have several languages to choose from.

Date/Time. The date/time setting is used to tell the camera what date and time it is. This is the time and date that will be linked to the saved file or to the time watermark if you chose that option. In this display, the OK button moves the highlighted square between day, date, etc. and the up and down buttons allow you to scroll through the numbers corresponding to month, day, hour, and so on. I've found my camera reverts to the factory default when the battery is removed. This is a bit of an annoyance. Remember to reset the time and date or you'll end up with your files having a date years in the past.

Format. The format setting allows you to format the SD card. A good practice is to use the camera to format your new cards and to reformat used cards when you've downloaded the images. Images and videos are still on the card when you delete them. Formatting will wipe the card clean allowing for somewhat better card performance.

My camera has two other choices in the settings menu. One is to reset the camera to factory settings and the other is to view the firmware version. If your camera starts to act up one idea is to reset the thing to the original settings. That way you're sure that nothing you messed with might be causing the errors or poor performance. The firmware option displays your camera's firmware number and installation or effective date. Your camera's manufacturer will likely have a support web page that lists the current firmware version and will have instructions on how to update your camera's firmware version. Firmware version changes may fix bugs found in the operating system or even add new features. If your camera is working OK and you're hesitant to make the change, skip it and leave well enough alone.

Exit mode.

The exit mode simply allows you to exit the settings menu locking in the changes you made to the various settings. My camera tells me to press OK to exit.

Conclusion

Your camera's settings are crucial to your getting the most from your action cam. It's very important that you're aware of your camera's settings each time you shoot.

Properly configured, your action cam will produce amazing images and video. When the settings don't match the situation, you'll be both frustrated and disappointed. Take some time around home at different times of the day and with different weather conditions and just play with the settings. You'll learn a lot that will make you a better action cam photographer.

Jim Mohan

Notes

CHAPTER 6
CAMERA ACCESSORIES

Introduction

Your action camera's accessories are what put the action in action camera. Without the multitude of accessories available for these cameras, your action camera is just a tiny video recorder. Accessories allow you to place your camera at an interesting angle and turn it on and let it go. Think 'look mom, no hands.' Without the accessories your camera is just another device you have to pay attention to and manage. With the accessories, you can focus your attention on the action, that is, the activity or sport that you're interested in recording.

The good news is most action cameras come with at least a couple of accessories. Many come with fairly large sets of accessories and accessory kits with upward of 50 pieces can be had for less than $30. Most kits use the same standard sizes as GoPro does so pieces and parts are normally easily interchangeable. Let's take a look at the common accessories and how you can put them to work.

Housings and Harnesses

Housings

As discussed earlier, the accessory that almost all cameras come with is their waterproof housing. Not only does the housing allow use underwater, it also protects the camera from rain, snow and even dust and sand. Basically, your camera's waterproof housing is a valuable tool for all but the most benign environments. With the attachment fittings we'll discuss later, you'll be able to attach it to almost anything.

Figure 8. Action cams in waterproof housings. Notice the significant differences between the cases for the two different camera brands.

Camera clips or clip fittings allow you to use the various attachment fittings without using the waterproof housing. It's like the housing without sides. Clip fittings are simply little trays your camera can snap into. The tray may have the familiar two curved hinge plates or just a ¼" by 20 tripod screw receiver. Clips with screw attachments usually come with a separate ¼" by 20 screw that includes the two curved hinge plates. Quarter inch by 20 screws are the standard size for tripod mounting screws. In fact, some action cameras come

with ¼" by 20 receiver nuts embedded in their cases.

Harnesses

Harnesses are the strap affairs that allow the camera to be worn. In fact, you'll sometimes see action cams categorized as 'wearable technology.' Depending on the harness, they can be made with 1 inch to 2 inch wide nylon straps and the typical snap connectors and adjustment buckles found on backpacks. You can find harnesses for both people and pets!

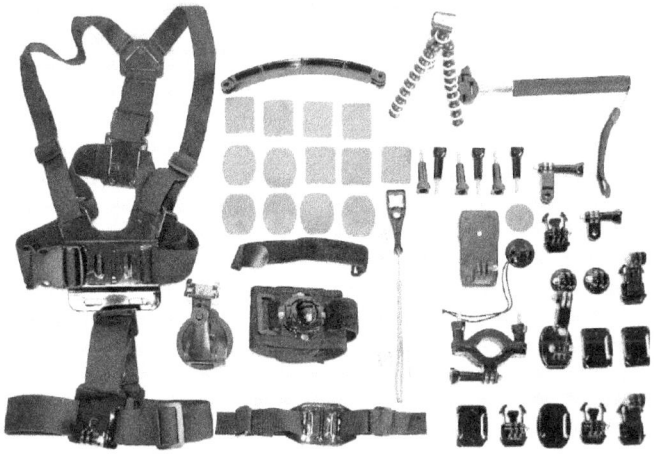

Figure 9. This 50 piece accessory kit includes harnesses, connectors, J hooks and a variety of other handy accessories. The light colored squares are foam adhesive mounts for more permanent attachments to things like skate boards or helmets. When purchased it cost less than $30.

Harnesses for People

A human harness will have a chest plate with a snap connector and the kit should come with a snap mount J hook. The J hook is the curved part with the three curved hinge plates that the camera housing or clip meshes with. The J hook and tightening thumbscrew is how you'll adjust the camera's angle. A chest harness will provide a lower point of view than a head

mounted harness.

Speaking of head mounted harnesses, head strap mounting systems use a head circumference strap and an over the top strap to secure the camera's mounting plate to your head. The mount is adjustable to get a snug fit both around your head and over the top. The top strap setting will determine how low the around-the-head straps will fit across your temples and back of your head. The head strap can be worn facing front or back and can be fitted to wear over a baseball-type hat.

Like the chest mount, the head mount strap has a mounting plate. Most come with a J hook molded into the mounting plate to affix the camera and control its angle. Head strap mounts provide a point of view that's more in line with your eyes. When adjusted to the same angle as your normal vision, the head strap mount will follow your view wherever you turn your head.

Harnesses for Pets.

I'm sure it didn't take long for someone to try to mount an action cam to their dog or cat. (Good luck with that cat thing!) Getting a pet's eye view of life can be both fun and interesting. Not long after those videos hit YouTube, some enterprising person undoubtedly designed and build one for sale. Now there are lots of choices for pet harnesses. These harnesses are adjustable and sized for dogs from just a few pounds to ones over 100 pounds.

Pet harnesses consist of a curved saddle that rests on the animal's back and straps to hold it tight. Like the human chest mount, they normally have snap connectors attached to the saddle and snap-style J hooks to attach the camera. Some pet harness include a chest mount attachment point which places a camera just under the dog's neck.

Depending on the story you're trying to tell with your video masterpiece, a pet harness can provide a unique point of view.

Attachment Techniques

Besides harnesses there are a bunch of techniques action camera buffs use to place their camera where the action is. Here are a few common ones.

Adhesive Mounts

Adhesive mounts are common parts to action cam accessory kits. The mounts use strong double stick foam tape to attach themselves to almost anything. The non-tape side of the mount will have a snap connector for a J hook and perhaps a ¼" by 20 tripod mount. Adhesive mounts allow you to mount a low profile attachment point to things like helmets or skateboards. When you want to use your action camera you just insert the J hook into the snap and set your camera's angle for the point of view you desire. Note that in many accessory kits, one of the adhesive mounts will have a slight curve and one will be flat. The curved mount will be better suited to most helmets allowing more of the adhesive tape to be in contact with the helmet's curved surface.

Figure 10. An adhesive clip mount and J hook were used to attach the action cam to the bed of this RC truck.

Bike Mounts

Most camera accessory kits will include a bike mount. Trail riding, BMX races and the kids riding around the neighborhood can all provide good action cam footage. Bike mounts include two rounded pieces that fit over a bike's handle bars or other round structural member. Those pieces are held tight by large thumbscrews on each side. One that I have would fit a circumference from between 15mm to 30mm not including the rubber gripper. The other side of the bike mount has the three curved hinge plates molded in to attach the camera, rotator or extension.

Figure 11. Action cam clip mounts. Mounts include an action cam remote control with a clip mount, the snap-in tray for camera mounting to various mounts and a hat bill mount with the camera and housing attached.

Clip Mounts

Clip mounts can be used to mount a camera to the strap of your backpack or the bill of a baseball cap. The clip mounts have heavy spring jaws that clamp onto a fairly narrow surface

like a pack's shoulder strap or a hat bill. The top of the clamp has the familiar curved hinge plates and thumbscrew to mount the camera. Clip mounts can be an easy replacement for harnesses or head strap mounts if you're already wearing a backpack or hat.

Suction Mounts

Suction mounts are pedestal mounts that allow the camera to be mounted to something smooth without the permanence of adhesive mounts. Suction mounts have a 2 to 3 inch suction cup on the bottom and a lever device that helps seal the mount to its mounting surface. Generally, surfaces have to be hard, smooth and flat for suction mounts to work well.

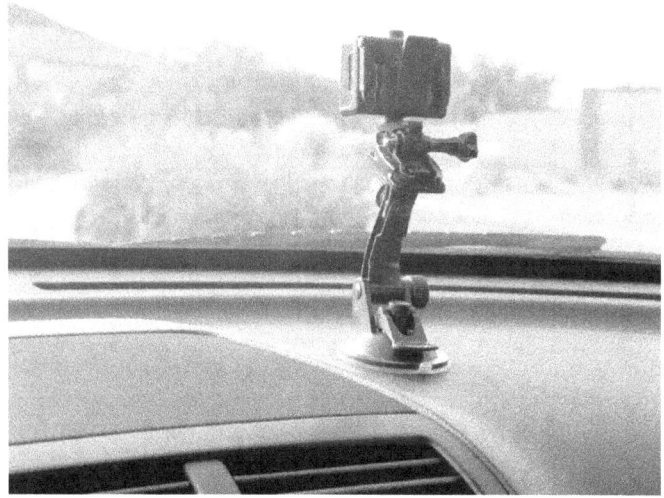

Figure 12. An action cam mounted in a clip tray attached to a suction mount on an automobile's dash.

Suction mounts can be used inside automobiles to frame conversations in the car or as dash cam mounts where the camera is pointed outside. Coupled with the wide angle nature of action cams, you can get nice interior views of the car if you're telling a story about the family vacation. I used a suction

mount in the front window of a tour bus to get some very nice footage of both city traffic and country landscapes.

The camera I was using had a remote control so I was able to start and stop the recording from my seat several rows back in the bus. Much of that footage turned into 'B-roll' footage bridging the gap between the various stops on the tour.

Float Mounts

Many third party accessory kits come with float mounts. These are normally bright yellow or orange mini-buoys with the common three curved hinge plates on one end and a tether of some kind on the other. The mini buoy can be used as a handle and provides enough floatation to bring your camera to the surface if you lose control of it. Using the often-included tether or wrist strap should prevent you losing it. Regardless, it's handier having the camera floating a few feet above you than dragging along the bottom while snorkeling or diving. In the pool, having the camera floating below the buoy can provide some nice footage, too. You'll need to rotate the video in post-production or select reverse image if your camera includes that option.

Selfie Sticks

Selfie sticks or monopods are extension poles that allow you to move the camera more than arm's length from you. These provide you with a range of interesting points of view to add to your video projects. At its simplest form, the monopod provides you with a tool to support the camera to reduce camera shake. That's a big deal with larger cameras but not so much with tiny action cams whose weight can be measured in grams.

Where these extensions come in handy in the action cam arena is to elevate the camera to get an over-the-crowd shot or dramatic over-the-cliff shot that would be too dangerous otherwise. Selfie sticks are also handy for – wait for it – selfies!

For video selfies you're able to hold the camera a foot or two away while talking to the camera about what's going on or what you're doing. With some practice, you can also get some good shots of you engaged in some action-packed activities. Skating, skateboarding, skiing and even bungie jumping can be captured with an extension pole.

Extension poles are also really handy when you have a camera assistant helping you with your recording. In these cases, your camera person can run beside you with the camera at an interesting angle while you do your extreme sports thing. The pole allows them to shoot up at you or get near enough for a nice close-up shot without putting either you or them in danger if you decide to change course unexpectedly or miss a stunt and wipe out.

Make sure you find a monopod that is strong enough to take some waving around with the camera and waterproof housing attached. Inexpensive cell phone selfie sticks may not be strong enough for the more active shots you'll be planning with your action cam.

Miscellaneous Connectors

If your camera came with an accessory kit, you've noticed a bewildering number of pieces. At first glance some appear to be the same. Others have some differences such as the length of the thumbscrews. Here's a quick rundown on what they are and how they're used.

Pieces with thumbscrews mounted though the three curved hinge plate side and an open two curved hinge plate side are rotators or pivot arms. If you look closely you'll see that the orientation of the hinges is different allowing you to connect one to a J hook and have rotation on two axes. You can also use one with the same hinge orientation to provide just a bit of extra clearance if you find the camera strikes the mounting plate before achieving the angle you desire. Just an extra inch in length can make a difference.

Figure 13. Notice the rotator attachment connected between the J hook adhesive mount and clip tray.

Some kits include a longer extension with the three hinge plates and thumbscrew on one end and a two hinge plate connector on the other. These extensions allow you to extend the camera out away from your bike or pedestal mount for a different point of view. For example, you could connect the extension to the bicycle mount allowing you to raise the camera more in line with your eyes' point of view. You could also do the same thing but reverse the camera to point back at yourself for some footage of you while you maneuver your bike. You could do the same thing with a helmet mount though a selfie shot with some of the shorter extensions might not make the minimum 8 – 12 inch focus range.

Lens Protection and Filters

If you dabble in photography and have a nice DSLR or mirrorless camera, you probably have a UV filter attached to your lens to protect it from scratches. Filters are cheap and lenses aren't. I've got UV filters on all my lenses. They allow nearly all the light to pass through and give me some cheap insurance against lens scratches. Serious hobbyists and

professional photographers may also have a set of various neutral density and colored filters to compose special effects by altering the light coming through the lens.

For the most part, such accessories are not available for inexpensive action cams. If you're going with a top-of-the-line action cam like the GoPro, you've got some choices, otherwise, not so much. As I've mentioned already, housings are specific to the camera it's made for. This also means that the lens part of the housing vary in size. Since most filters snap onto the outside of the housing, that variability is not your friend. One solution is to find someone who has a GoPro housing and measure the front lens frame (the black part with all the little screws). If your housing matches, you'll know a GoPro filter kit will work.

Some filters allow you to enhance your underwater video by filtering out light in the water that can lead to murkiness or color issues. Your filter kit's instructions will explain each filter's use.

As for lens protection, for most cameras you'll just need to be careful. Some brands have soft silicon lens covers to use when storing your camera or when it's in your pocket. Many do not. As with filters, you can see how your lens' diameter compares to the cameras that come with caps and go with one of those if they match. Unfortunately, lens diameter is not a reported specification so you'll need to find someone with a camera that has a lens cap or perhaps find one in a store to measure.

Extra Batteries

Batteries don't last forever and there's nothing more frustrating that running out of power before you run out of day. Some cameras come with more than one battery, but a busy day or overnight adventure may mean missed opportunities if you only have a couple of batteries.

Fortunately, many camera brands come with chargers and batteries that are sold separately. With some extra research

online, you might also be able to find someone who has used a third party battery with your brand of camera.

My advice is to get one of the kits with a couple of batteries and a charger. The charger may or may not come with an AC plug. Not a big deal. You've probably already got an AC connector and USB cable with the right size plug. If you record a lot or do some camping trips, grab one of the small 12 volt USB plugs you can insert into the power outlet in your car. If you're really roughing it, take along a 10000 or 12000mAh cell phone battery charger to power your action cam charger. Some even come with solar panels so you can actually recharge them by setting them in the sun.

Conclusion

As you can see there are lots of handy accessories for your action cam. The majority of them are used to help you mount your camera in some interesting way or at some compelling angle. The good news is that for the beginner, accessory kits are cheap and will give you a chance to try all kinds of interesting shots. Be smart about using your mounting methods. Tethers are good tools to use as backups if the primary mount fails. You'll lose the shot but not the camera.

Putting a suction mount on the outside of your car and driving down the road at 30 MPH is likely OK. Placing it on your car and driving 80 MPH down the freeway might not be such a good idea. You'll want the right tool for the right job.

CHAPTER 7
CAMERA GIMBALS

Introduction

Camera gimbals are accessories too, but unique enough to warrant a separate chapter. There are lots of creative applications that have sprung from the cell phone industry. Miniature GPS receivers, tiny Wi-Fi broadcast transmitters and small accelerometers or inertial measurement units (IMUs) are just a few. Many of these engineering marvels have found their way into the action cam arena.

Camera gimbals make use of IMU technology.

What Gimbals Do

The idea behind a camera gimbal is pretty simple. The gimbal keeps the camera steady when the camera operator is moving. Gimbals for large cameras often use weights attached to free moving frames and use gravity to hold the camera still while the camera operator moves around. In fact, you can find a number of do-it-yourself videos on YouTube to build your

own stabilizer.

While the gravity technique will work on an action cams, too, the relative size and weight of the contraption defeats the purpose of the action cam form factor. Enter the electronic gimbal.

How Electronic Gimbals Work

Electronic gimbals for action cams are fairly small handheld devices onto which the action cam is mounted. Once mounted, the gimbal is turned on and depending on brand and model, it initializes to a forward facing (relative to the handle), level orientation. The gimbal uses small brushless motors instead of gravity to keep the camera steady.

Inertial measurement units in the gimbal detect motion and the computer processor uses those signals to instruct the gimbals' motors to move opposite the movement. The result is a smooth steady video image that resembles movements shot from camera dollies or expensive large, fluid head tripod mounts. The up and down jerkiness is greatly reduced and the overall quality of the video is dramatically enhanced.

Gimbal Levels and Features

There are a couple of predominate brands in the small handheld gimbal space. The two leading brands are pretty similar in models, features, performance and Amazon and other product reviews. They are both Chinese companies -- Feiyu Tech and ZhiYun. They are not the only brands but are two of the big ones in this market.

Both companies have a similar line-up of gimbals with similar price points and features. At the lower end of the price point are 3-axis gimbals with a couple of operating modes. The primary difference in the low end gimbal and the next version up is the exterior ribbon cables from the processor module to the motors. The newer versions have the cables embedded in

the motor mounting arms. As you go up the price points the gimbals add some features. One of the handy features in top-of-the-line handheld action cam gimbals is the ability to automatically adjust to when the gimbal is held upside down.

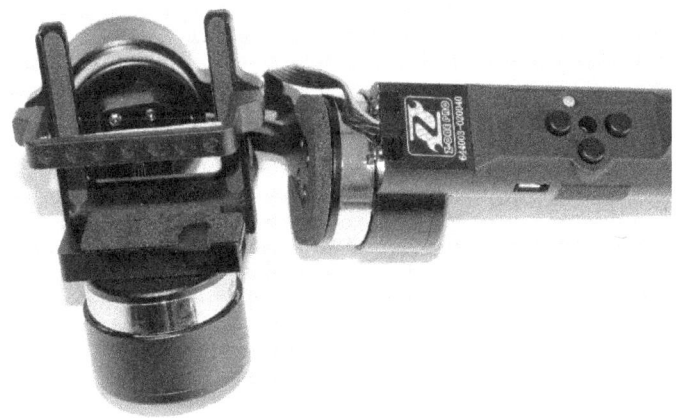

Figure 14. Mounting bracket and gimbal controls for a ZhiYun Z1 Pro gimbal.

The other aspect of handheld gimbals you'll need to be aware of is the size and style of the mounting bracket. Gimbal mounting brackets generally fit GoPro cameras and even then, not always the full line of GoPros. When viewing the gimbal's specifications, look to see what GoPro it's built to fit. Find that camera's dimensions and compare those to yours. You've got some flexibility when it comes to camera length and width but most mounts aren't forgiving of height variations. As these tools have become more popular, you can find models with some adjustability. Be sure to understand mounting dimensions before you purchase your gimbal.

There are a couple other things you should be aware of.

Gimbals can be had with alternate mounting brackets. For example, the ZhiYun Z1 'Rider' model can be attached to a motorcycle or bike providing dampening to the bounces from trails or bumps in the road. Feiyu Tech has a wearable 3 axis gimbal that can be attached to a helmet. The other thing to be mindful of is models that allow you to mount a smartphone instead of an action cam. Those mounting plates aren't going to work for your action cam. Last, the gimbals' motors have weight limits. They are designed to move a camera the size and weight of a typical action cam. Larger cameras or heavier phones need more powerful motors. Be sure to do some research to match your gimbal to your needs.

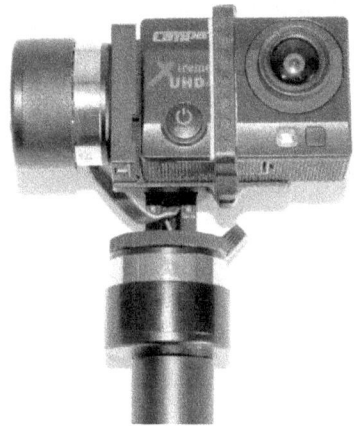

Figure 15. An action camera mounted in a ZhiYun gimbal.

Gimbal Modes

Gimbals operate in several basic modes. Let's take a look.

Heading Follow Mode.

In heading follow mode the camera's heading stays aligned to the direction represented by the front of the handle. This means that as you rotate the handle, the camera will stay

aligned with the handle. The pitch axis is active helping reduce the jumpiness of the video that occurs when walking or jogging. The other neat feature of this mode is that the camera doesn't move as fast as you might when pivoting from right to left or vice versa. That means you can abruptly change heading while the gimbal slowly and smoothly pans to your new heading. The result is a much smoother more attractive video shot.

Locking Mode.

In locking or locked mode, the camera remains pointed in the direction it was pointed when you enter this mode. When in this mode you can move the gimbal's handle side to side or up and down and the camera will stay pointed at the same point. This mode allows you to move around your target while the gimbal keeps the camera pointed at the target.

Heading and Pitch Follow Mode.

In heading and pitch follow mode, the gimbal will point the camera relative to the front of the handle and at the pitch set by the pitch controls. Like the heading follow mode, the camera stays aligned with the front of the handle. Additionally, it also stays aligned with the pitch selected with the pitch control buttons or joystick. It keeps those parameters when the gimbal is moved slowly. When the gimbal is moved rapidly, the camera will slowly follow along to the new direction. In the pitch axis, if the camera is moved faster than the motors can follow, the pitch will also slowly realign as the handle stops moving. Again, this results in a smooth pan to the new heading while maintaining pitch regardless of the handle's angle.

Reverse Mode.

Reverse mode in many of the higher-end gimbals is really not a separate mode. The gimbal will simply reverse the camera's direction when the handle is pointed down. This mode

prevents the gimbal's motor from getting in the camera's frame or shot. You can simulate this in some lower cost models by going into the heading and pitch follow mode and moving the gimbal so it's upside down. The pitch follows the motion so the motors stays behind the camera. Start a new video file when doing this as the camera will be upside down. Either use the rotate video mode if your camera supports that or plan to reverse the video in post-production.

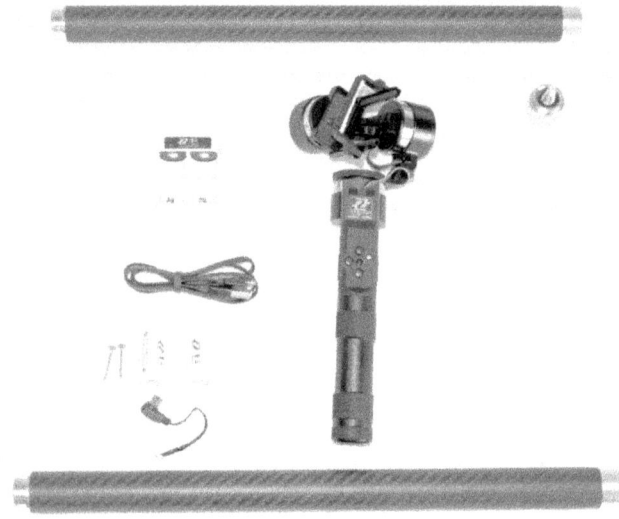

Figure 16. Typical gimbal kit with gimbal, batteries, charger, USB cable and camera power cable. Brand specific extension poles are usually sold separately.

Controlling the Gimbal

Most gimbals have an on/off button either at the base of the handle or along the grip. Modes are selected by pressing the mode button once, twice, or three times in quick succession to select modes one, two or three. You'll need to check your gimbal's instructions to see what mode described above applies to each mode selection on your brand.

Gimbals often have a small LED indicator that flashes indicating the mode the gimbal's in. One flash for mode one and so on. A single press on the mode button brings it back to its base or mode one setting. In the gimbal in the photographs the mode button is to the left.

The other two buttons are the pitch and roll buttons. Depending on the mode selected, pressing the upper button points the camera up in small increments and the lower button points the camera down. Again, depending on the mode, the same buttons can rotate the camera left or right. This way you can align the camera with horizon if it's off or purposely induce an angle for some creative effect. Depending on brand and price point, these buttons are sometimes replaced with small thumb-style joysticks.

Extension Poles.

Gimbal manufacturers sometimes offer extension poles. These poles provide the same functionality as selfie sticks used without gimbals. The primary differences with gimbal-specific extension poles are their strength and mounting connectors.

Gimbal extension poles are often made from aluminum tubes or carbon fiber. These pole have to support not only the weight of the camera but also the weight of the gimbal itself. This is not insignificant. While gimbals aren't heavy, they're not light either. These poles often mount by screwing into the threads on the bottom of the gimbal. Since the thread patterns and diameters aren't the same from brand to brand and even within brand models, you need to be careful when selecting extensions. Normally, your best bet is to find poles that come from the same manufacturer and for the model you have.

If extension poles are part of your plan, you might want to make sure you get a gimbal that has a matching pole you can purchase.

Conclusion

Most gimbal owners will agree that a gimbal is one of the best investments they made to improve the overall quality of their videos. There are plenty of YouTube reviews of various gimbals both from manufacturers and users. Side by side comparisons where the reviewer uses side-by-side action cams are simply striking. If you are considering becoming the next big YouTube sensation, you'll want to consider adding a gimbal to your toolkit.

Unfortunately, if you're using an inexpensive action cam, the gimbal can cost two to five times the cost of the camera itself – ouch. If you're serious about action cam photography, start saving.

CHAPTER 8
QUADCOPTERS AND DRONES

Introduction

Like camera gimbals, radio controlled quadcopters and drones are action cam accessories that are significant enough to demand their own chapter.

One of the complicating factors regarding drone usage is the fact that the FAA in the United States and similar governmental bodies in other countries own the airspace in which the drones operate. What that means to the drone operator is regulations. In the US the FAA refers to drones technically as small Unmanned Aerial Systems and Unmanned Aerial Systems for larger machines.

Whole books are written about drones. This summary will be brief but give you some insights into whether these cool tools might be something you'll want to pursue.

For the most part I'll refer to these aircraft as quadcopters, quads or drones. Other configurations are also used.

How Drones Work

As with gimbals, cell phone technologies found an interesting application in the drone world. Micro-sized GPS receivers, camera sensors, and IMUs (inertial measurement units) to measure vertical and horizontal accelerations are among the technologies employed in drones.

Drones use inputs from these sensors to provide inputs to the propellers in a way that controls altitude, rotational motions, left and right movements, and forward and back movements.

Drones have what are often called 'A' and 'B' propellers that have blades that are reversed. The drone's controller board translates the inputs from the RC transmitter to control the rotational speed of each of the propellers.

By varying the propellers' speeds the drone goes up and down, forward and back, side to side and rotates clockwise and counter clockwise. Advanced electronic devices and the ability to program those devices allows drones to do some really cool things.

Pushing the throttle up causes the quadcopter (or multi-copter) to climb. All the propellers spin faster causing the craft to rise. Reduced RPM causes the drone to descend. Similarly, pressing the left stick to the right or left causes the appropriate props to change speed resulting in a rotation to the left or right. Moving left and right or fore and aft is controlled the same way using the stick on the right side of the controller. Altering the speed of various propeller combinations maneuvers the drone.

Drones with GPS receivers can fly a preprogrammed route over the ground. Many drones can automatically return to where they were launched with the touch of a button. Their onboard computing capabilities allow them to compare their current position read from the GPS receiver with either the preplanned route or their launch point coordinates and maneuver to those points in space. Even drones in the 'toy' category have excellent stability control and will hover when

you just stop moving the controls.

Because of these advanced electronic devices, quadcopters are very easy to fly. Drones in the $500 to $1000 range can be mastered in just a few flights. These camera drones are easy to fly as their purpose is to obtain great video footage. RC pilots who fly model airplanes will find these devices fairly boring to fly. But again, exciting flying is not the goal, great video is.

For many hobbyists, the fact that the drone flies is almost an afterthought. Learning how to best use the telemetry and programing the devices to do complicated flight plans becomes the main focus of the hobby.

Using Drones as a Camera Platform

One of the very first uses of the early drones was use as a camera platform. Small cameras like our action cams were mounted to either fixed or adjustable gimbals to record airborne videos or stills.

While early drones were often built from kits or parts allowing the builder to equip the craft to meet his or her purposes, it wasn't long before manufacturers started producing complete high quality camera platforms. Drones like the DJI Phantom series and the Blade Chroma were released and became very popular. As these products began to dominate the market, just like with action cams, low cost versions emerged with impressive capabilities. Now quadcopters in the $350 range rival the capabilities of the $1000 drones.

These drones have small cameras mounted below the drone's body. Many of the cameras in these drones are 4K cameras that produce excellent results. In some cases the camera is mounted to a gimbal that is controllable from the ground. The gimbal can be set to just smooth out the video but can also be set to stay focused on point or target or scan the ground around the drone. These features allow drones to be used for search and rescue and even agricultural crop assessments.

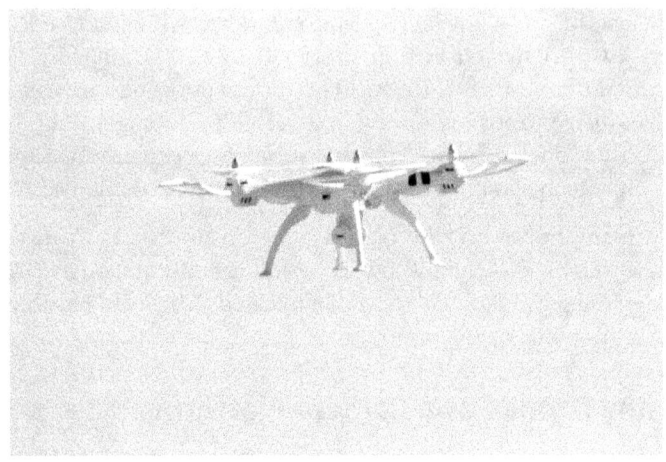

Figure 17. A camera drone with an action camera suspended below the drone's body.

Camera and Gimbal Choices

One way the manufacturers of inexpensive quadcopters keep the costs down is by excluding the camera and gimbal from the kit. These quads will come with a fixed but adjustable camera mount sized to fit a camera such as a GoPro. This gives you a choice in the cost and quality of your camera. Fixed mounts allow you to set the camera's angle for the shot from the quad and use the quad's heading to direct it.

The next step up is to mount a powered gimbal such as models from the brands mentioned in the chapter on gimbals. These small gimbals can be powered by separate batteries mounted to the drone or gimbal or tapped from the drone's main battery. Some gimbals claim to be adjustable through open RC receiver channels. Since most quadcopter kits come with proprietary 2.4 GHz transmitters, it's wise to spend some time researching any compatibility issues. Online modeling communities such as www.RCGroups.com would be a good place to start.

Flight Modes and GPS

With quadcopters in the $300 and up range, you'll either get embedded command modes or external telemetry accessory options that allow you to control your drone from your cell phone or tablet using GPS satellite data and an app.

Most quads that have these features have these or some subset of these flight modes.

Mission Planning or Autonomous Mode. In this mode you upload mission way points from your phone. Using Google Maps you can download a map of the area you fly over and select waypoints by touching the screen. The waypoints are uploaded wirelessly to the quadcopter. When you execute the mission, the quad will take off, fly to the specified altitude and maneuver from way point to way point. When it reaches the last way point it will normally return to its takeoff point.

Return to Home Mode. With return to home mode, you can either touch an icon on your phone or tablet or click a switch on your transmitter and the quad will rise or descend to a predetermined altitude and maneuver to its launch point. Once over the launch point, it will slowly descend and gently touch down without any input from the operator. Touchdowns are often within inches of the original launch point.

Return on Signal Loss Mode. Return on signal loss is a safety feature. If you were to fly the drone too far away or otherwise interrupt the signal from the transmitter, the quad will revert to return to home mode and come back to its launch point.

Follow Me Mode. This mode allows you to specify an altitude and distance that the drone will follow the telemetry transmitter. Using this mode you can film yourself walking through an area with an airborne perspective. There are often three related follow me modes. Lead me mode causes the drone to fly in front of you as you walk or run along. Follow me left and follow me right modes cause the drone to place

itself to your left or right and fly abeam you as you move.

Keep in mind that a best practice is to have an assistant with the transmitter who can take over if things go wrong. Additionally, you'll want to set up these camera shots when others aren't around. Flying over others is not safe and will likely result in a conversation with law enforcement. If you're a member of the Academy of Model Aeronautics (discussed below), there are published safety codes for autonomous models you agreed to abide by when you joined.

Commercial vs. Personal Use

I mentioned in the introduction to this chapter that drones are regulated by many national governments. In the United States, the Federal Aviation Administration categorizes drones in two basic categories. Those categories are commercial and personal use.

Commercial use includes any purpose where the use results in you getting paid for something. This could be taking a look at the quality of a roof if you work for a roofing company, taking nice airborne shots of a property for a real estate company or using a drone to follow an actor through the woods during the production of a movie.

The FAA after some years' delay, has published rules for commercial use. These rules include certification for operators and a host of safety measures.

Personal use of drones are limited to devices under 55 pounds. From the FAA's point of view, all RC model airplanes are drones. A consumer level camera drone weighs nowhere near 55 pounds. A DJI Phantom drone, for example, weighs in at just under three pounds.

The FAA has published guidelines for individuals using small drones. If you choose to add a drone to your camera's accessory toolkit, you'll need to register with the FAA as a drone operator. When you register, you'll be presented with all

the guidelines with which you'll need to comply. The rules are somewhat different if you are a modeler and a member of the Academy of Model Aeronautics. If you're an AMA member, you need to follow the AMA Safety Code. You can get more information at the AMA's website and join the AMA at http://www.modelaircraft.org/.

You'll have some homework to do if you decide to use a drone with your action cam video projects. Start by registering at https://registermyuas.faa.gov/.

Drone Safety

There are all kinds of stories about how drone operators fly their drones in an unsafe manner. Some of these stories are myths but enough are true to wonder how sane some people are.

Flying a drone near airplanes is illegal. So is flying one in an area where firefighters are battling a wild fire. Yet, some knuckleheads do it. Drones shouldn't be flown over groups of people. That means the drone shot of the crowd at the big game was likely illegal. This seems pretty obvious but you still see YouTube videos where drones were flown stupidly.

It seems pretty funny when you see video of a photographer flying his drone and he hits the happy couple. Unfortunately, the injury that scarred the bride, ruined the gown and delayed the ceremony probably wasn't funny at all. While I'm not referring to a specific event, many drones have the power to inflict significant injuries. Camera drones can add an exciting perspective to your videos but fly them safely.

There's a brief discussion on privacy in chapter 10. A drone's maneuverability can cause you to run afoul of privacy ordinances quite easily. Be mindful of others.

Conclusion

Disruptive technologies are often accompanied by controversy.

High tech drones are no exception. Politicians, regulators, opinion columnists and others all have some great fear of what is unusual or not understood. Drone users add to this controversy by doing dumb stuff.

A recent article from a British newspaper where they seem to have mounted a crusade to ban drones is an example. The headline talked about a drone-related death. Only after reading the article did you find that the death occurred when someone who had earlier been flying a drone ran from police and had a car crash.

Your camera drone can be a great tool to take your video production to an entirely different level. They are easy to fly, can result in breathtaking shots and provide hours of enjoyment to amateur film makers. Take the time to become aware of the rules regarding drone operation and fly safe.

CHAPTER 9
GETTING THE MOST FROM YOUR ACTION CAMERA

Introduction

Just taking pictures and recording video isn't particularly satisfying. Viewing your video on the 2 inch screen on the back of your camera or viewing it in the video viewer on your computer doesn't bring much satisfaction either. What makes the video fun is sharing it with friends and doing a little showing off—either what you did or where you've been.

To avoid the old cliché of inviting friends to watch your vacation slides and boring them to tears, you need to give a little thought to why you're recording the video or taking the photos and what you want to do with them when you're done. In this chapter we'll spend some time discussing how you might answer those questions and get the most from your camera.

Get to Know Your Camera

The first thing you'll need to do to get the most from your action camera is to understand its settings and how to configure the camera to provide the result you're looking for.

The Camera Settings chapter described the most common settings found on action cameras. Knowing what they are is a start but having practiced using them is the key. The best way to get to know your camera is to keep it with you and record in a variety of settings. Going to the mall? Take it along and record some random footage at various exposure settings and frame rates. Set the camera to photo mode and shoot a couple of minutes of timed shots in the Auto mode.

Same with the park or skate park. Are some friends going to ride? Bring you camera and a mount or two and shoot some footage. Work on the angles, exposure settings and mount types to get a sense of what the results are. Spend some time with your video viewer or editor and make some mental notes about what worked and what didn't.

When exploring the different variables at your disposal, consider making some notes listing such things as the exposure settings and white balance mode. That will give you some insights into if and when to make adjustments in various locations. When in video mode, say the variable settings out loud to get them recorded with the video.

With a Windows-based computer you can right click on the image in the Windows File Explorer and display a Properties dialog box. If you click on the 'Details' tab you'll see much of the metadata recorded with the image. You'll be able see and compare several of the camera's variables between shots. I've found that when using the exposure control variable, for example, the camera, has elected to vary the shutter speed in one comparison and vary the ISO in another.

For those really into photography, the metadata also includes aperture, focal length, shutter speed and ISO.

Telling the Story

Most of the time you have a purpose for taking your action cam with you and going through the extra steps to set it up and attach it to the appropriate accessory. That purpose might be just a fuzzy idea of an end result or something fairly specific. Regardless, that purpose involves telling a story.

A story might be a chronological review of a road trip or family vacation, documenting a do-it-yourself craft or project, or the thrill of racing down a ski slope. Whatever it is, telling that story is going to take some planning. The chances you'll end up with the photos and footage you'll need to tell your story are pretty remote if you think about the story only after you return from your outing.

As with most presentations, you need to give some thought to your story's purpose, audience and point of view. Most stories have as one of their purposes to entertain. Another common purpose is to inform. Drilling down deeper, purposes may include documenting family life, providing detailed how-to information or advocating for one thing or another. Regardless of your story's purpose, having given it some thought before picking up your camera is critical.

Assessing who you are directing your story towards is also important. Stories about how to do one thing or another differ greatly depending on whom they are focused. Let's assume a component to our story is about providing some skiing advice. A video directed at novices might spend a bunch of time on equipment and adjusting it properly. A video directed at experts might omit equipment altogether while instead focusing on the mental aspects of assessing the run, snow conditions and the like. That translates into what and how your photos and video are shot.

A video for a novice might include more broad shots of the environment and close-ups on boots, ski adjustments and the like. Action footage during the run might include views

directed at your feet and if you're using an assistant, shots of how you use your poles during a fairly docile slide down the run. On the other hand, a video directed at experienced skiers might begin with a broad shot down the hill long enough for voice over dialog about what you're thinking about as you assess the hill. The action footage will be more aggressive with a mixture of angles showing the big picture down the hill to describe adjustment strategies and angles showing footwork used in faster, more aggressive runs.

As I mentioned before, in a project where I documented a trip, I used an action cam mounted in the front window of the tour bus to get a bunch of footage through the windshield. That footage became the transitional footage both between tour destinations and the beginning and end of each day. Using camera features such as time-lapse, you can insert short clips indicating the passage of time or the movement from location to location. More on time-lapse later.

Even a three minute YouTube video should have a story. With the story in mind, you're much more likely to return home with the images that will allow you to tell it.

Planning the Shots

With your story in mind, the next step in producing a successful video is planning the shots. You've probably seen movie story boards with every shot and angle meticulously planned. Unless you're actually planning a cinematic feature, such planning is probably overkill. What's not overkill is envisioning the end result of your video and making some notes on the shots, angles and points of view you'll want to tell your story.

A short video of a day on the lake enjoying some skiing and tubing with friends doesn't take a lot of effort but a shot plan will help you avoid things like finding out you didn't get any shots of your girl or boy friend. (Oops!) More involved stories may require you to actually list the shots you want and even

document how you'll shoot them. For example, shots with a gimbal for smooth video while loading the car, shots with a suction mount on the windshield for some of the conversation during the drive, a chest mount for shots on water skis and a wrist mount for shots with several people on the big inflatable you'll pull behind the boat. You may plan to shoot the evening beach campfire from a tripod using the time-lapse mode to compress those activities into just a few seconds.

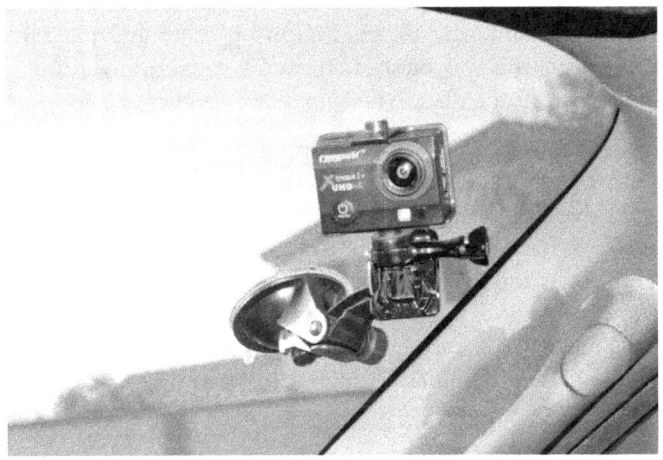

Figure 18. An action cam mounted to a car's inside windshield with a suction mount to capture in-the-car video.

Shot planning will help prevent you spending time in your video editing software wishing you had filmed that perfect event that would have tied everything together.

This information applies to just about any shooting situation and camera, not just action cameras. In fact, your story may involve footage from several different cameras—both action cams and not.

Continuing with the lake example, if you have friends with action cams or have a more traditional video camera at your disposal, your shooting options grow significantly. You can get simultaneous shots of someone water skiing from the shore,

from another skier's first person view and from the skier's chest mount harness. Such footage can be edited together to really bring the viewer into the scene.

Shooting B-roll

The last thing we'll discuss in this section on shot planning is shooting what's often referred to as B-roll. In this case it is nothing more than letting the camera roll during non-action times or shooting the location showing other activities, other people using the area or shots from the car window during the trip to or from the planned destination.

B-roll footage gives you the opportunity to tie your story together with video transitions. In a concert setting, B-roll is crowd shots that can be shown during songs to add interest to the video. B-roll doesn't have to be recorded sequentially with the main action or story. The shots are generic enough to insert anywhere as a cut away shot or use as a transition to a later time. B-roll audio can also be used under action cam footage where the camera's audio is bad or non-existent.

I once attended a concert that was being recorded for television. Before the concert started, the producer came out on stage and asked the audience to clap and cheer and do typical audience things so the camera operators could get B-roll footage. Several cameras spent several minutes collecting B-roll that was edited into the songs as crowd shots as they were performed.

Using Multiple Cameras

Multiple action cameras allow you to capture both forward looking and rear facing shots of the same activity. As with the skiing example, if you add a partner shooting a third wider framing shot, the three views can be edited together for a fast-paced sequence.

It's certainly possible to reshoot the scenes with different

points of view but a savvy viewer my notice different lighting, sky conditions or other background features that don't quite add up. Unless you're shooting a feature film, the fact that a helmet mounted camera might be seen in the rear facing view shouldn't matter too much. And don't forget the valuable footage you can get from someone shooting the wide views on a handycam or smartphone.

All this requires some extra coordination to be sure. But if you have a group of friends who share your interest in the activity and photography, the production tasks can be a big part of a fun day being together and having a record of the activities when you're done. Action camera filming definitely doesn't have to be a solo activity!

Capturing Sound

I've often heard it said that more than half of a video's perceived quality is the audio. When working with an action camera you're at a bit of a disadvantage in this regard. Tiny pin-hole mics and cameras sealed into waterproof housings produce basically awful audio.

There are a couple of things you can do to overcome this built in shortcoming.

Some more expensive action cams have adapters that allow the USB port to connect to an external microphone. Such mics will be much better than the pin-hole mics but can still leave much to be desired. You can find both mic adapters that allow your mic's 3.5mm TRS plug to attach to the camera's mini USB port and mics with mini USB ports that can connect directly. Sub $150 action cams are unlikely to include this capability.

The second alternative is to record your audio separately. This isn't as complicated or expensive as you might think. Before examining this alternative more closely, let's take a little detour into how to use a microphone more effectively.

Kinds of Microphone

Let's look at just a couple of mic types and styles so you'll know what to look for. First the types.

Microphone Types

You'll be looking for two basic types of mics. The first is a condenser mic and the second is a dynamic mic. Condenser mics require power to translate the sound vibrations they pick up into the electrical signal that runs down the mic cord to the recorder. Most external smartphone mics are condenser mics with the smartphone providing the power. Shotgun style mics are usually condenser mics, too. They have a battery compartment built into their housing and the battery provides the voltage. Condenser mics need a power source. You'll need to verify that the mic is self-powered or your device (smartphone or recorder) provides the power.

Figure 19. An A.lav brand smartphone lavaliere microphone with a Galaxy smartphone.

Dynamic mics don't require power and are fairly rugged. You'll

often find them used as stage mics for bands and announcers. Dynamic mics don't provide as strong a signal to the recording device as do condenser mics. That means the recording device needs audio circuitry designed for them.

Microphone Styles

Mics come in a number of form factors. We'll look at just two.

The first is the lavaliere mic. These mics clip onto the speaker or are hidden in clothing close to the speaker's mouth. You've seen newscasters with lav mics, I'm sure. This is because any mic needs to be up close to the speaker if the goal is to record spoken words or dialog. When the mic gets more than two to three feet away from the speaker, it starts to sound like the speaker is talking into a barrel and you'll hear lots of extra ambient noise. Lav mics are usually omnidirectional meaning they pick up sound from all directions.

The second mic style we'll look at is the shotgun mic. These are the long tube-like mics that you'll see on the sidelines of a football game. They will often have a furry windscreen mounted along their barrels to reduce wind noise. These mics have sound pickup patterns that reduce the sound captured from the sides and enhance the sound pickup to the front. These mics really aren't much better at dialog from a distance than any other mic but are great for capturing your location's ambient sounds. Now, let's get back to recording your audio separately.

Using Separate Audio Recorders

If your goal is to record dialog you're going to almost certainly need to record your audio separately. You might even find that a separate audio recorder is a good choice for the sound of skis on snow or the grunts and deep breaths rock climbing. In these settings, your smartphone and an external smartphone lav mic are a good choice. There are lots of free audio recorder apps at your smartphone's app store. Set the app to record at

the sampling rate you desire, normally 44.1 kHz, and the file type you want it saved in. Then route the mic cord through your clothes to avoid snagging anything and clip it to your shirt or jacket. Press play and start the camera and you're on your way. Before starting your task, clap your hands in the camera frame loud enough to be heard to provide a marker for post-production audio syncing.

To record a conversation among friends while in a car or when shooting a wide shot around a campfire or at the coffee shop, consider using an inexpensive audio recorder such as the TASCAM DR-05 or Zoom H1. These small, handheld recorders have built in microphones and can be adjusted to capture audio much better than a smartphone app. The recorder can be placed out of the camera's view and the sound will be much better than what you'd get from the camera alone or even with a camera-mounted external mic.

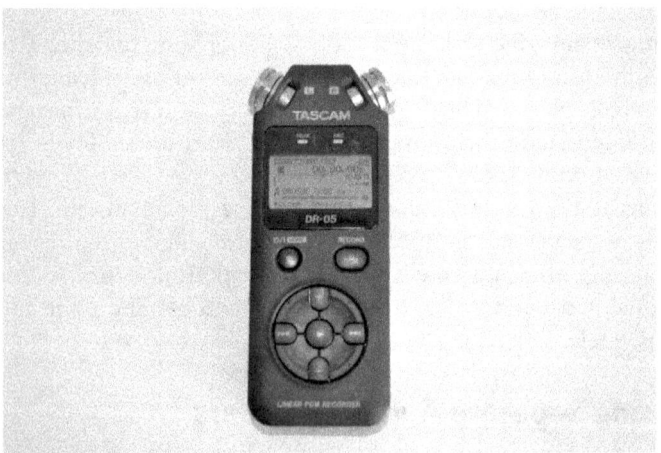

Figure 20. A small digital audio recorder like this TASCAM DR-05 is a great tool to enhance audio recording for your videos.

You can also use your external recorder with a shotgun mic to record the wide view sounds. What I mean by that is either alone or with another camera such as a handycam, you can shoot the same scene from a distance that your action camera

is capturing up close. That will provide you with an audio track that can play under the action cam's footage. This capture technique is almost always required around water as the mics and recorders don't do well submerged! I'll talk more about this in the next chapter.

Conclusion

There are two key points to this chapter on getting the most from your action camera. Both are in large part mental. First you need to be familiar with your camera's settings to get good video when you shoot. Second you need to do some planning to ensure you're able to tell the story when you start working in your video editor. With some practice and thoughtfulness, you'll quickly develop the skills needed to consistently produce great videos from your action cam.

Jim Mohan

Notes

CHAPTER 10
EDITING YOUR FOOTAGE

Introduction

There are two parts to editing your action cam footage. One is the software and the other is the art. In this chapter we'll discuss some of the tools you'll need to turn your video footage and photos into a production you'll be proud of. We'll also discuss some of the things you should think about so you'll end up with what you had envisioned.

By necessity, this will be a pretty high level view. After all, you can get college degrees in this topic. With a couple of insights and other online resources, you'll be off to a good start.

Editing Software

Editing software is pretty easy to find. Some of it is free such as Windows Movie Maker and iMovie. There are lots of choices in the $30 to $130 range. More expensive software usually includes more effects and transitions and can handle more recording tracks where you can overlay titles, voiceovers,

background music and the like. For the casual user, Windows Movie Maker, Pinnacle Studio, and Power Director are good choices. There are also several choices of consumer level products for the Mac. If you're a Mac person, check to see what's already on your machine. You could be good to go already.

Modern video editing software is often referred to as non-destructive and nonlinear editing software. This means that when you import your footage into your video project, the original footage isn't changed or destroyed and your video clips can be put together in any order. Your editor basically records the clips, cuts, trims and effects you apply to your footage and uses those instructions to render your various video files into one new video. Each of the original video files used in the project remain unaffected. You're free to use those files again in another project without any evidence of the changes made in an earlier project.

Your editor, especially paid editors, allow you to apply a variety of effects to your videos. You can correct colors, apply artistic color effects, pan and zoom using key frames and apply a host of transitions from one scene to the next. Be judicious on your use of fancy digital transitions and effects. When it comes to these effects, more is definitely not better. You want your viewer focused on the images, not the transitions. The best transitions are those that people don't even notice. Straight cuts and blends should be your predominate tools.

Editor Workspaces

The typical video editing software presents a workspace that is divided into several areas. Most of your editing will be done in what's called the timeline. The timeline usually has at least a couple of tracks where your video is represented as a box whose length is measured on a time scale. That's why it's called the timeline.

You'll drop videos or parts of videos into the timeline to build

your new video project. The other tracks in the timeline can be used to place other elements of the video. For example, you may place a title element into one of the timeline tracks or place an MP3 version of a song into one of the tracks.

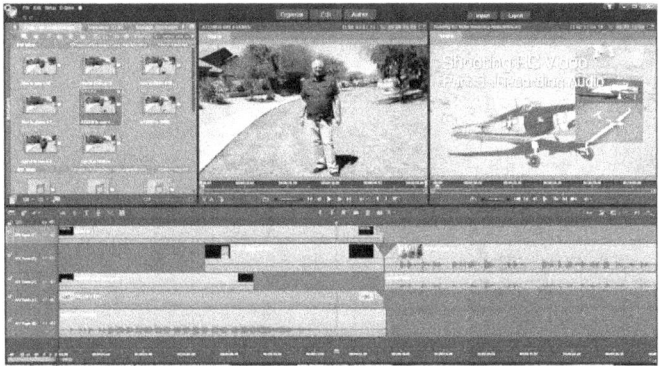

Figure 21. The video editing workspace in Pinnacle Studio 19. Notice the library space top left, preview window top middle and project viewer top right. The multi-track timeline is below.

Video editors usually display the top track. By stacking video elements correctly, you can build a video with a title that overlays the video images and an audio track that plays throughout.

Besides the timeline, your video editing software will also take some screen space for either one or two video viewers. The viewers display the video selected in the video library and the video already placed in the timeline. Single video displays only show the video in the timeline.

Depending on the editor, you'll also find space reserved for displaying available transitions and other digital effects. What's displayed will depend upon what folder is selected in the program's library or file folder display.

Editing controls and other actions are accessed through the top menu system, small icons or pop-up menus activated with a right mouse click, or other keyboard combinations.

Editing as an Art

Quick Hits and Multiple Perspectives

The art of editing like most art is in the eye of the beholder. However, there are some common techniques that should be considered before going too Avant-garde.

When it comes to action cam footage, quick hits are part of the mix. High energy activities need high energy editing. What that translates to is frequent changes in perspective. The first few seconds of your trip down the ski slope are cool. By the time you get to a minute, however, folk's attention will be drifting.

To keep your viewer interested, you should be changing perspective every four to five seconds. This can include alternating from your first person view to your rear facing view to the wide view shot by your partner going down the slope behind you. This is where the shot planning exercise comes into play. If you have the chest mount and the rear facing helmet mount on an extender, you don't want your wide shot assistant with a front facing helmet mount to go first. With the proper footage obtained, your editing can be an action-packed run down the hill with a combination of wide shots, first person views and shots of you concentrating on the run.

This same technique holds true for other activities too. Even when you're filming a competition, a minute of someone swimming across a pool can seem like forever. Take a look at some professionally edited action sports. The perspective changes every few seconds. Even a TV golf broadcast changes cameras frequently. Either plan for an assistant or partner with a friend to get at least two views or zoom factors of the action. Remember, yours or your friend's smartphone video recorder is a good choice for your second or third perspective and you've already got it with you.

Software Tools and Effects

As mentioned earlier, your editing software likely has some powerful effects you should be familiar with. One of the tools you'll want to use is color correction. If your footage comes from different days or different times of the day, the colors may not match. This becomes most noticeable when doing a straight cut and the overall brightness changes. If the scene changes from outside to inside or day to evening, that's OK, your audience will anticipate the change. However, when both scenes are daylight scenes you'll want to correct them. This can occur when your camera meters the light differently between shots or when using footage from several different cameras. You can also use color effects to accomplish a dramatic or artistic purpose. Video editing software often has color isolation effects or grayscale or sepia effects to alter your footage. Remember, the changes you make to your footage don't affect the original file. The color correction only occurs in the current project.

Paid editors such as Pinnacle Studio or Power Director come bundled with some really neat features that can set your video apart when used judiciously. Video montages are a great way to open your video project. Using these effects, you can insert several snippets of video or still shots or a combination of the two to form the primary effect for your introduction or title shot. You can often layer effects resulting in striking opening scenes that will capture you audience's attention. Montages can also be used as transitions between scenes when the settings are quite different. If you project is more fun than serious, transitions where the preceding scenes shatters and falls to the bottom of the screen revealing the start of the next shot can add some whimsy and fun.

Effects like picture in picture allows you to run two or more videos at the same time. For example you can run the wide shot as the background video while showing the first person view in the window or vice versa. These kinds of effects provide additional options for perspective changes that keep

your video interesting.

Again, don't go wild on the effects. The goal is to enhance the story, not overpower it with digital magic.

Also, don't get too scared by the mediocre reviews these paid programs receive on Amazon. The fact is that video editors require a lot of computing power. Crashes occur and it can be frustrating to have to restart the program. If you have an old or bare-bones computer, consider trying one of the free programs. If one of those doesn't meet your expectations, you can simply try another one. My experience with Pinnacle Studio is the edits I make are recorded immediately and my project will be where I left it when the program restarts.

The next step up on the editing software ladder is to move into professional programs such as those in the Adobe Creative Suite or Final Cut Pro for the Mac.

Fisheye Correction

Since we're dealing with action cam footage here, there is going to be a fisheye effect to your images—both video and stills. As described earlier, the fisheye effect is a result of the deeply curved lens needed to capture the wide field of view when using tiny lenses. The simple lens construction and shallow focal distance results in rays of light curving as they come through the lens without the correction that's applied in larger more complicated lenses. These curved light rays hitting the camera's sensor result in images appearing curved, especially near the edges.

Figure 22. Notice how the trees are curved in towards the center of the photo and the hill to the left curves near the top. Compare it to the corrected version.

Figure 23. Here the fisheye effect has been removed. Notice that the trees are straight and the hill does not curve at the top left of the photo.

Depending on your project, you may want to remove the fisheye effect and its potential distraction. You can find standalone programs that will remove the fisheye effect from action cam footage. If you are using a GoPro brand camera, the GoPro Studio app will also do this and it's free. It looks for specific file settings to screen out video from other action cams, though. It will likely not work with footage from another brand's camera.

There's another Windows standalone program from ProDad called ProDrenalin. It includes color correction and image stabilization in addition to fisheye removal for a host of different cameras. You can download a trail version to see if it works with your camera. The same company offers a more expensive fisheye correction program called deFishr. It doesn't include the color and stabilization components of ProDrenalin but it does allow you to build a custom profile for your specific camera lens to accurately remove fisheye.

My advice would be to try ProDrenalin for free and if your camera isn't supported, go with the more expensive product. While not listed by name, videos from one of my inexpensive action cameras converted nicely using a profile from a similar camera included with the package. If you have a GoPro, go with their Studio app.

Corel Paintshop Pro X8 removes fisheye from photos with a single click. Other photo editing software will also fix fisheye curves in photos. As you can see in the example photographs, fisheye can be quite distracting and removing it greatly improves the image. Unless you're going for some kind of artistic statement, you'll want to fix your images.

If you haven't been editing your footage using a video editing tool, please consider doing so. Even an hour cutting bad footage and adding some titles or voice over makes a huge difference. Several editors have in-depth tutorials online that will help you come up to speed quickly and greatly improve the overall impact of your footage.

Some Legal Stuff

First, I'm not a lawyer. Get your specific legal advice from your attorney. There are some general things you need to be aware of, though, if for no other reason than you'll know to ask the question.

Privacy

There are times and places where cameras freak people out. You may remember the controversy when Google Glass head mounted devices first came out. You also hear a lot about people's fears of drones recording them through windows or behind the privacy walls of their backyards. On the other hand, cameras at a gathering at a restaurant or a recognized tourist attraction are hardly noticed.

Different states have different laws about recording people. Hidden recording may require one or both parties to know about the recording based on states' wiretap laws. Recordings made when people have an expectation of privacy are often restricted. Dressing rooms and bathrooms are a good example of this. In fact, as I was writing this book, the local TV news reported the arrest of someone using a smart phone to record a young girl in a department store dressing room. That person had been charged with several felonies.

Generally, there is no expectation of privacy in a public place. Street shots or shots taken from the street are not normally prohibited. The commercial use of those shots may have some restrictions, however.

If your video project is a bit more complicated or possibly risqué, do some research and check with a legal advisor before getting started. Your female co-worker could make life difficult for you if her topless water wipeout ends up on YouTube without her permission.

Copyright

Your videos are your work and when you post them to YouTube you'll have the chance to specify the copyright protections you claim. This can be the standard YouTube license or a Creative Commons license. Creative Commons licenses strive to reduce restrictions on using others' work to advance creative endeavors.

What your photograph or video records may be copyrighted, though. I'm sure you've seen reality TV shows with product names blurred out on vending machines or on hats. Those are attempts to stay out of copyright troubles.

Most of the time, a non-commercial project isn't worth the copyright holder's time coming after you. If you have a trademark on a vending machine in your video it might even be protected. However, inserting commercial video footage or still shots into your video could get you a lawyer letter or a law suit. One of the inadvertent ways your video could infringe on someone's copyright is when there is music playing from a loudspeaker or radio that's recorded with your video footage. YouTube has computer bots that scan videos and report when they 'hear' a song that their owners hold the copyright to.

You can avoid most copyright issues by not using footage, photos or music you don't have rights to. There are lots of stock photo sites online where you can get photos for your project for free or at a very low price. Same with music. One of the easiest to use is YouTube itself. It has a large selection of music available for you to use for free. Read the license as you may have to credit the source in the credits portion of your video.

Your video editor, too, may have access to royalty free music libraries or even electronic composers that will custom build a musical score based on the genre, theme and variation you select.

Regardless how much you like a song, if you don't have

permission to use it, don't.

Conclusion

Editing your footage to produce a great story about your adventure adds value to your recording. Not only do you get to relive the adventure while editing, your audience gets to enjoy a coherent story, often with stunning video.

Editing tools don't have to break the bank. Many are free and the ultimate cost is only the time you take to learn to use them effectively.

Jim Mohan

Notes

CHAPTER 11
TEN TIPS FOR ACTION CAMERAS

Introduction

There is no shortage of ideas about getting the most from your action camera. This chapter includes ten tips for you to consider when using your action cam. Some are from the body of the text and others didn't make the cut for the text but are worth a short blurb anyway.

The Ten Tips

Do your homework. Take the time to become familiar with all your camera's settings and capabilities. This includes practicing. I've heard it said that the difference between an amateur and a professional is that the amateur practices until they can do something right. A professional practices until they can't do it wrong.

Take it with you. Great skills and a great location mean nothing if the camera is at home. Get in the habit of carrying your camera in your pocket or purse. You never know when

you'll stumble upon the terrific street scene you need for a video project, a wonderful street performer or a really great sunrise while out for an early morning hike.

Use accessories creatively. Even an inexpensive accessory kit will give you enough combinations to come up with some really creative camera mounts. Suction mounts on the inside of a car windshield can provide both inside and outside points of view. Your bike mount can point forward or backward. An adhesive snap mount on the front of your skateboard provides a unique point of view of your favorite obstacle.

Frame the shot. After you've got the camera mounted, take some test footage or a sample photo to make sure the camera is pointed where you want it. A phone app with in-camera Wi-Fi is a great framing tool.

Update angles and settings. Don't assume camera mounts and conditions will stay the same all day. Recheck the mounts to ensure they're still tight and still pointed where you want them. If the morning sun has turned to a dull cloudy afternoon, make exposure and white balance adjustments.

Tell your story. Decide what the story will be for your outing. Examples could be, 'a day with friends,' 'mastering the bunny slope,' or 'fishing cutthroat creek.' Have a sense of what the end result will look like.

Plan your shots. As you think about the story you're planning to tell, think about the key shots you'll need to tell that story. Make a list. For a significant project, add details such as mounts, angles, direction, normal or slow motion and so on.

Use burst, auto and time lapse modes. Your camera shoots more than video. Use these modes to add creative effects to your projects.

Take what you'll need. Review your shot list and be sure to include the accessories you'll need to complete the list. You'll be disappointed when you discover you left your bike mount at home when the goal was shooting you riding an awesome

forest trail. Will you need a hat or helmet mount? How about your selfie stick or extra batteries?

Work with friends. Include those you're going out with in the planning and shooting. Get your buddy to shoot the over-the-shoulder shot from behind you with your selfie stick. Let one of your friends ride ahead and set up a wide shot of you riding or jogging down the trail. Getting them interested in the recording process adds to their enjoyment of the day, too.

Bonus Tips

Be respectful of others. Be mindful of those around you. Don't monopolize a setting while you shoot multiple takes blocking others from enjoying the site or sights. Don't assume others want to be part of your video. Let groups pass and then take your shot. Close-ups of strangers can be problematic.

Edit your footage. Action cam phone apps make it easy to share your footage on social media. That's great for a quick shot of landing a fish or your child laughing at the petting zoo. Resist the urge to post longer scenes without first spending some time with your video editor. Your audience will appreciate it.

Conclusion

I hope you've enjoyed this book and have gotten some insights into how to get the most from your action camera. These little cameras have amazing capabilities for what is sometimes, a very low price. While not exactly a 'throw away' item, their relative inexpensive prices allow you to have a couple and not feel bad about risking the camera in a fall or other extreme sports incident.

If you are a gadget person, one of these cameras really fills that niche with opportunities to try and do all kinds of fun things.

Now, all you have to do is go for it.

Photo Credits

Chapter 3

Figure 3. By Sensor_sizes_overlaid.svg: Moxfyre derivative work:Rodrigo Tetsuo Argenton (Sensor_sizes_overlaid.svg) [CC BY-SA 3.0 (http://creativecommons.org/licenses/by-sa/3.0) or GFDL (http://www.gnu.org/copyleft/fdl.html)], via Wikimedia Commons

Figure 4. By Pablo Contreras H. (Own work) [CC BY-SA 4.0 (http://creativecommons.org/licenses/by-sa/4.0)], via Wikimedia Commons

Chapter 10

Figure 22. By Drm1804 (Own work) [CC BY-SA 4.0 (http://creativecommons.org/licenses/by-sa/4.0)], via Wikimedia Commons

Figure 23. By Drm1804 (Own work) [CC BY-SA 4.0 (http://creativecommons.org/licenses/by-sa/4.0)], via Wikimedia Commons (fisheye correction applied)

All other images By Jim Mohan (Own work) [CC BY-SA 4.0 (http://creativecommons.org/licenses/by-sa/4.0)]

ABOUT THE AUTHOR

Jim Mohan is a long-time radio controlled modeler, educator and trainer. Jim is a twenty-year Air Force veteran who served as a pilot, instructor pilot, classroom trainer and staff officer. His second career was as a training leader in a Fortune 200 corporation. He has also served as adjunct faculty at the community college, undergraduate and graduate levels.

He first added an action camera to a flying model nearly a decade ago and has since developed his interest in many aspects of photography including filming flying videos of radio controlled airplanes and build and assembly logs of a variety of models.

Jim's videos are on his YouTube channel, The RCPlaneviews.com Channel. If you have comments on this book, you can email him at jim@rcplaneviews.com

www.ingramcontent.com/pod-product-compliance
Lightning Source LLC
Chambersburg PA
CBHW071822200526
45169CB00018B/696